NEW KENSINGTON

THE PHOTOGRAPHIC HISTORY

GEORGE GUIDO

Printed and bound in the United States of America.

ISBN: 978-1-63385-151-1
Library of Congress Control Number: 2016909469

$19.95

Published by
Word Association Publishers
205 Fifth Avenue
Tarentum, Pennsylvania 15084

www.wordassociation.com
1.800.827.7903

ACKNOWLEGEMENTS

TO PUT A BOOK PROJECT LIKE THIS TOGETHER TAKES THE HELP OF MANY PEOPLE.

In particular, I'd like to thank the City Administration of New Kensington, Mayor Thomas Guzzo, City Clerk Dennis Scarpaniti

From the New Kensington Bureau of Fire, Edward Saliba, Jr., Assistant Fire Chief.

From People's Library, Dave Hrinvak; Jamie Stoner, Curator at the Allegheny Valley Heritage Museum; Henry Holt Publishing

From the Valley News Dispatch, Managing Editor Jeff Domenick, photographer Jason Bridge, who is also a NKVFD member.

From the Facebook site: Old Pictures and Stories of New Ken, James Sabulsky of Lower Burrell.

Sculptor and New Kensington native Stephen Paulovich of Louisville, Ky.

From the Alle-Kiski Sports Hall of Fame, Chairman Bob Tatrn.

Last, but not least, my wife Brenda Paulsen Guido, whom I had the good fortune to marry on May 31, 1980. Thank you for your patience, companionship and constant encouragement of my endeavors.

CONTENTS

POSTCARDS

Some of the pictures in this book are actual postcards with historic sites of New Kensington. The value of postcards in the city's history is important. While they are nice collector's items, postcards were also used by European immigrants who came to the region, searching for a better life. The immigrants were able to communicate with parents, relatives and friends in their countries of origin and also allow them to see a photographic example of where they settled.

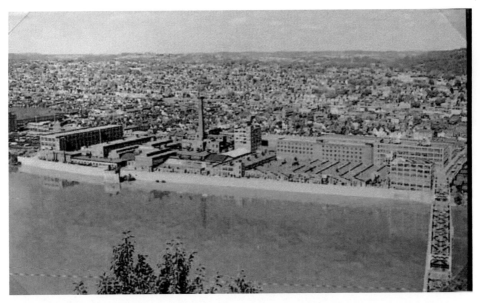

Here is the iconic "Birds-eye view" photo of downtown New Kensington, taken from Bouquet Hill. It is believed to have been taken around 1958, before any of the downtown and adjacent redevelopment was started.

This photo has been used in various publications, including post cards once sold in the Pittsburgh region.

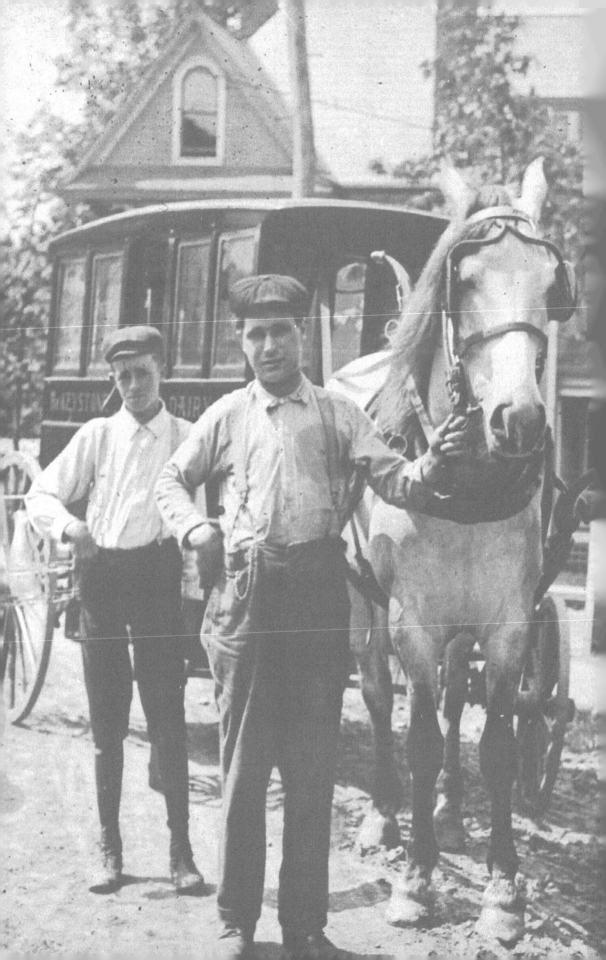

INTRODUCTION

New Kensington celebrates its 125th anniversary in 2016. Following are historical excerpts from the 1966 New Kensington Diamond Jubilee Book written by Mrs. Luella Rodgers Frazier; the 1991 Celebrating a Century Book edited by Mrs. Elizabeth Bissell; the Ken-Hi 1900-2000 reunion book; "Lore of Yore" by the New Kensington Woman's Club in 1986; the book "Alle-Kiski Sports History" by this author and various articles that have appeared in the Valley News Dispatch and its predecessor publications.

History records that in 1669-70 French explorer Robert Chevalier DeLaSalle and his voyagers came gliding down what we now know as the Allegheny River. DeLaSalle, age 26 at the time, and his voyagers were on a journey they believed might take them to China.

We can surely speculate what he and his aides might have said or thought as they passed the flat flood plain of New Kensington. They likely noticed the wide valley of the Pucketos and Little Pucketa Creek and where the tributaries merged into the Allegheny.

Perhaps the party may have encamped here and made minor explorations.

The area was certainly inhabited by Native Americans and embodied the true forest primeval. Woodlands full of animals – streams full of fish.

DeLaSalle's journey ended when he discovered the Mississippi River Valley and claimed all the land he explored - including our area - for France.

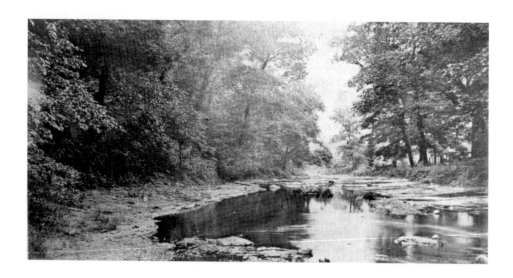

This is how the Little Pucketa Creek at 4th Street looked in 1890.

Baron de Longueuil led 442 men down the Allegheny River in 1739. Contrecoeur, who would later command Fort Duquesne, was a member of the expedition.

At the same time, land in Eastern Pennsylvania and the eastern part of the continent were, according to England's governmental system, the property of the English King, to do with as he pleased.

To satisfy a debt owed from the British Crown to Admiral William Penn, a donation of the tract of land now known as Pennsylvania was made to his heir, also named William.

The younger Penn was a Quaker and a favorite in the Court of King Charles II.

Governor Penn made a treaty in 1736 with five Native American nations – the Mohawks, the Oneidas, the Cayugas, the Onondagas and the Senecas (the Tuscaroras later came on board) – to control all the land within Penn's Woods, later to be known as Pennsylvania.

The treaty of 1736 was later supplanted by another made in Albany in 1754 that conveyed to the Penns all the land "westward to the setting sun."

While the French, who still considered most of Western Pennsylvania theirs, developed a relationship with the Native Americans who claimed their nations didn't have the authority to enter into the Treaty of Albany.

This led to the French & Indian War, with both parties siding against the British.

After England won the French & Indian War, settlement was opened up west of the Allegheny Mountains.

Creating Westmoreland County

Bedford County was established on March 9, 1771 and extended toward the Allegheny River.

Native American tribes, particularly the Iroquois, considered the Allegheny and Ohio Rivers one and the same.

When the Delaware tribe, part of the Algonquin nation, displaced the Iroquois tribe in the 18th Century, they used the term "WELHIK-HENY," meaning "beautiful stream."

When the settlers arrived from the eastern part of the state, they anglicized the term to "Allegheny."

With Bedford County opening land offices, the floodgates were opened for settlers, mostly of Scotch-Irish and German descent, to head for the wilderness of Western Pennsylvania.

Land was priced at 5 British pounds sterling per 100 acres. Converted to 2016 U.S. dollars, that's about $7.04 for 100 acres of land.

They settled along the river, feeling this land would quickly grow in value.

Arthur St. Clair watched over the Penn Family's interest vigilantly. He saw a need for a county west of the Allegheny Mountains and petitioned The

Crown, feeling that Bedford County was too remote to govern the quickly-settled territory.

The British obliged, creating Westmoreland County on Feb. 6, 1773. The county got its name from a town in England that has similar topography as our home county.

The first major land sale in what we now know as New Kensington was bought by John Little. In April, 1769, Little paid, to the Colonial government of Pennsylvania, $181.76 for a nearly 300-acre parcel of land. He named the site "Parnassus," after a mountain in Greece.

Benjamin Armitage purchased the adjacent land in which he called "Hermitage" – later to be known as New Kensington.

In another big land sale, Robert McCrea bought 300 acres in what later would be called Arnold.

These three parcels of land comprised the present area from Logan's Ferry north to Valley Camp.

With the Revolutionary War winding down, the patent for the Parnassus area was granted to Little by the Commonwealth of Pennsylvania on July 20, 1781. The patent description was "beginning at a Spanish White Oak opposite the Sewickley Old Town (Springdale) and bounded to the East by barren land."

Carving out a new city

The area's first official municipality was Allegheny Township, formed in 1796. It served the northwestern corner of Westmoreland County.

In 1852, citizens petitioned the Westmoreland County courts for the creation of a new township.

Judge Jeremiah Murry Burrell, presiding judge at the time, granted the petition.

The newly-formed municipality was called Burrell Township in honor of the Judge, whose maternal grandmother was a member of the Murry family, for whom nearby Murrysville was named.

After serving three terms in the Pennsylvania Legislature, Burrell was appointed as a Westmoreland County Judge to fill the unexpired term of Judge Thomas White.

In 1855, President Franklin Pierce appointed Judge Burrell to the District Court of the Kansas Territory.

Suffering from laryngitis and fever, he returned to Greensburg where he died on Oct. 21, 1856 at age 41.

Efforts to establish a more efficient government led to another petition to the Westmoreland County courts in 1877 requesting that Burrell Township be divided into two municipalities. The court decreed that the request be placed on the ballot for Election Day.

On Nov. 5, 1878, electors voted 114-6 to divide Burrell into two municipalities. The vote was certified on Jan. 18, 1879, thus forming Lower Burrell and Upper Burrell townships.

Parnassus had already been incorporated as a borough on April 9, 1872.

But before that, the Allegheny Valley Railroad was completed in 1855-56. It offered transportation from Pittsburg (spelled without the 'h' at the time) to Kittanning.

In July of 1890, the Burrell Improvement Co. , a major player in land dealings in the Pittsburg region, purchased a large tract of land in Hermitage.

Burrell Improvement, led by company President Samuel E. Moore, laid out what was called the town of Kensington in June, 1891. The company offered free train rides for those interested.

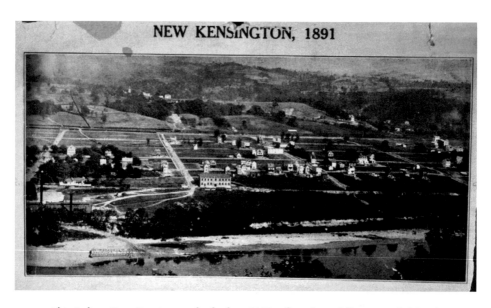

NEW KENSINGTON, 1891

This is how New Kensington looked in 1891, after the wildly successful land sale engineered by Burrell Improvement Co.

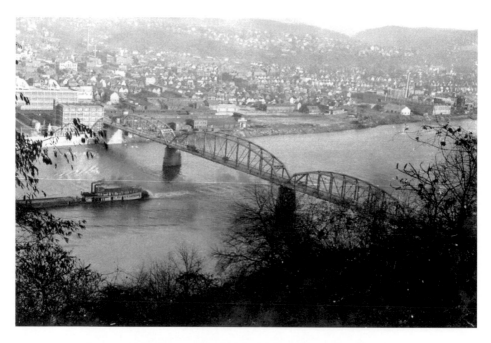

This is a 1933 photo taken by Ken High student Clarence Susek. The 9th St. Bridge was six years old at the time.

About 15,000 people showed up.

The price scale of the first several hundred lots varied from $30 to $300. New residents sold their cattle and raised money as best they could to get in on the ground floor.

The first lot was lot was sold at the corner of 5th Avenue and 9th Street. The third lot was sold to D. A. Leslie at the corner of 5th Avenue and 10th Street, where he opened the first drug store.

The opening day's sale totaled $63,000. At the end of the three-day extravaganza, $135,000 in lots had been realized.

A plowed furrow marked the boundaries of each section and each lot.

By 1892, 500 houses had been built. Westmoreland County Judge Lucien W. Doty made the order to incorporate the Borough of Kensington on Nov. 28, 1892. The territory included all land north of Parnassus to Valley Camp, including the present City of Arnold.

The Kensington boom was said to be without precedent in Pennsylvania.

The new borough was named after the town of Kensington, England. But post office officials discovered there was already a town in Pennsylvania named Kensington in the Philadelphia area.

That led to the prefix "New" being added.

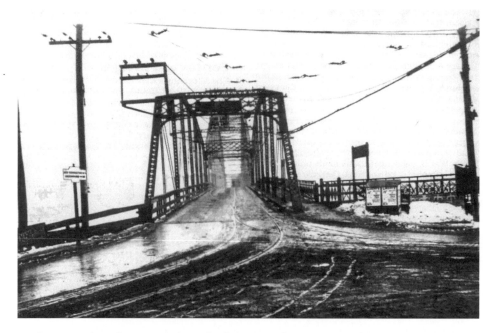

The original Ninth Street Bridge, also known as the Bouquet Bridge, was narrow and made for streetcars. When the automobile was popularized, it was difficult for cars to pass each other in opposite directions.

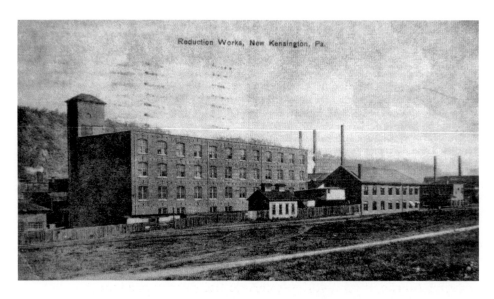

This is an early photo of the Pittsburgh Reduction Company on the riverfront, the forerunner of the Aluminum Company of America.

The new borough was divided into two wards, with the area now known as Arnold comprising the Second Ward.

Things weren't always rosy for the new community. In October, 1895, a movement was begun to incorporate the Second Ward as a separate borough.

Since the withdrawal seemed to be the only way to make peace, there was no opposition to the separation of the two communities, and Arnold Borough was formed in January, 1896.

Expanding the town

Despite the loss of what now is Arnold, New Kensington soon grew.

The hill area on the east side of the railroad tracks was quickly being developed.

East Kensington was developed in 1906 by the New Kensington Land Company. The first plan extended to the west to Wood Street, the south and east by 7th Street and the north by what is now known as Powers Drive as farmland was being turned into residential areas.

In 1910, the first plan of lots in Valley Heights was laid out. It was originally known as Grandview Heights.

Development of Mount Vernon began in 1915 in what was then Lower Burrell Township. George J. Deininger purchased the first lot on 478 Summit Street on Oct. 15, 1915.

A ravine had to be filled in order to connect Riverview Drive with 7th Street. Lenus Hileman, father of future Mayor Lenus H. Hileman, filled the ravine with a former brick road.

As Mount Vernon grew, street names were given names of battle sites, military divisions and personalities from World War I. Streets such as Argonne, Marne, Pershing, Keystone and Rainbow popped up.

Access to Mount Vernon improved greatly in 1917 when Parnassus Borough built the Fourth Street bridge across Little Pucketa Creek and W.W. Schultz

was contracted to build the winding road along the hillside to connect with Center Avenue.

In November, 1919, the remaining 255 Mount Vernon lots were turned over to the newly-formed Mount Vernon Improvement Company.

Parnassus annexed the 300-acre area from Lower Burrell in 1919.

The McKean Plan was laid out in 1916 and the land in the upper part of the hill, including Charles and Highland avenues, was annexed from Lower Burrell in 1917.

Pine Manor was developed by Henry Saxman of Latrobe in 1925-26. Local wags called it "Pine Manure," since the land had been part of a large dairy farm owned by the Rev. O.H. Miller, his son J Kerwin and his daughter Ruth Miller Doty.

In 1930, New Kensington annexed Valley Heights, Valley Camp and East Kensington from Lower Burrell.

Immediately, Hills I and II were developed by Fred Broad. Many mine and mill workers settled there because it offered ground for small gardens, and for raising chickens, geese, ducks and cows to be used for personal consumption.

In the election of 1930, voters decided to consolidate New Kensington with Parnassus.

Up to that point, Parnassus was its own municipality for 58 years. It had its own borough building, its own school system and its own police and fire service.

The Parnassus Town Hall and fire department was on Main Street.
The Parnassus high rise was built on the site in 1973.

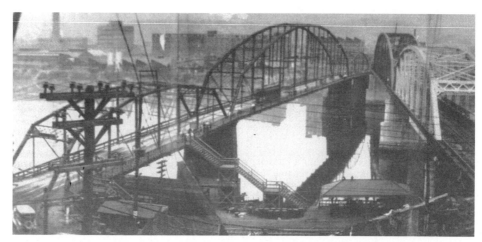

Credit: Allegheny Valley Heritage Museum

From 1927-29, the 9th Street Bridge complimented the Bouquet Bridge,
built in 1900. Note the Bouquet Railroad station at the lower level.

Here is how Parnassus Plaza looked on May 17, 1958.

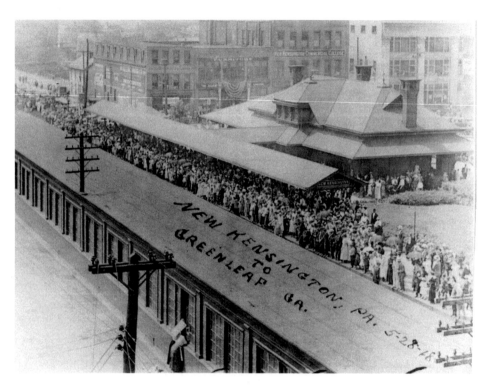

Thousands await the return of troops at the New Kensington train station from Greenleaf, Ga, on May 28, 1918. The troops had completed duties in World War I.

ALUMINUM CITY TERRACE

As World War II approached and the demand for housing to accommodate needed workers at Alcoa, the U.S. Public Building Administration commissioned famed architect Walter Gropius and his partner Marcel Breuer to design the Defense Housing Project.

The site was later named the Aluminum City Terrace.

The project was started in May, 1941 on an emergency basis. Less than a month later, all the drawing and specifications for the 250-family project was completed.

The design was regarded as "radical" by many New Kensington residents. Criticism was directed at the severity of the building exteriors and against the fact that multi-unit housing was new to a town that consisted chiefly of single-dwelling homes.

The storm over the concept eventually subsided during World War II, but it wasn't the end for controversy at the Terrace.

The federal government was going to tear the 35 buildings down after the war and after the New Kensington City administration rejected a use for low-rent housing.

The residents were happy there, however, and wanted to stay.

After eight months of complicated legal maneuvers and negotiations with banks and the federal housing administration, the tenants formed the Aluminum City Terrace Housing Association in September, 1948.

The association is a corporation owned by the tenants and governed by a Board of Directors.

The neighborhood has withstood the test of time 75 years later.

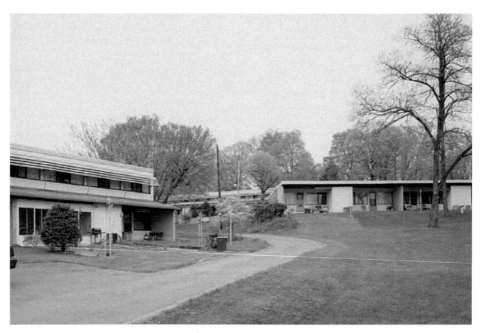

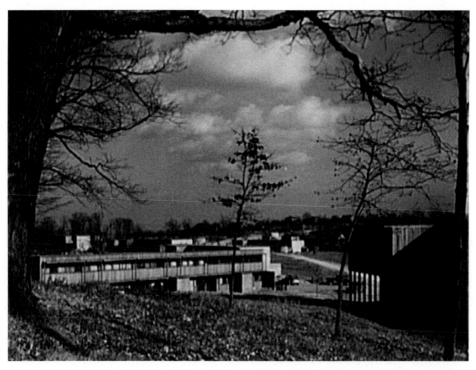

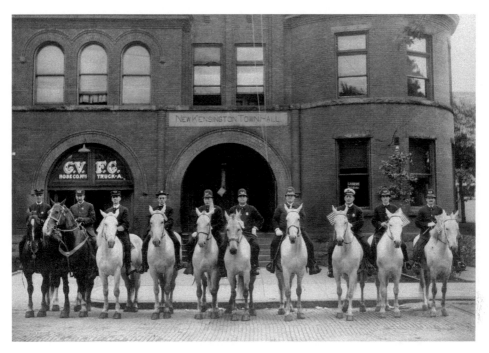

Before motorized vehicles became common, the New Kensington police
mounted horses to get around.

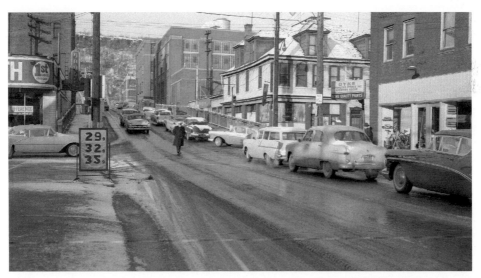

Credit Valley News Dispatch

Commuters encountered traffic getting to work in Springdale, Creighton
and other towns on the western side of the Allegheny River. Gas was cheap
and fueling up was no problem. When this photo was taken on Feb. 11, 1959,
there were 32 gasoline stations in New Kensington.

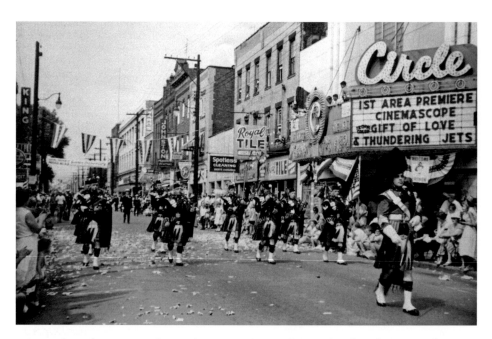

A parade makes its way along 5th Ave. in 1959 as the Loyal Order of Moose Lodge 43 celebrated its 50th anniversary. Note that one of the movies at the Circle Theatre was "Gift of Love," starring Robert Stack and Lauren Bacall. It was the next to the last movie Stack would make before taking on the role of federal agent Eliot Ness in "The Untouchables" TV series, the role that defined his career.

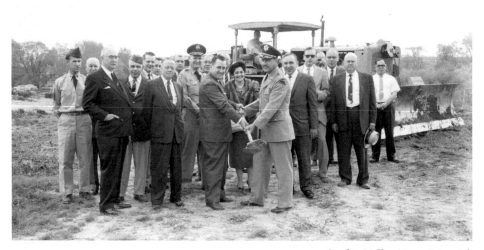

Credit: Valley News Dispatch

Groundbreaking took place at the U.S. Army Reserve unit along Craigdell Road on May 1, 1958. Major Samuel Smith joined Mayor Raymond Gardlock for the ceremony. The local unit was formerly headquartered in Glassmere, East Deer Township.

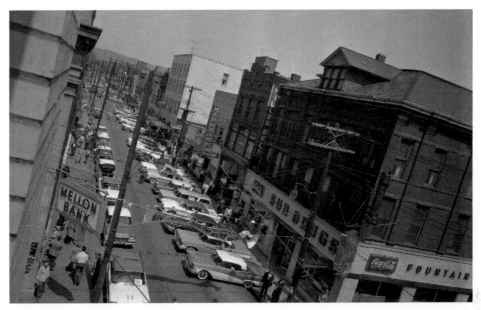

Credit: Valley News Dispatch

Here is a look at the New Kensington Auto Show along 5th Ave. in April of 1958.

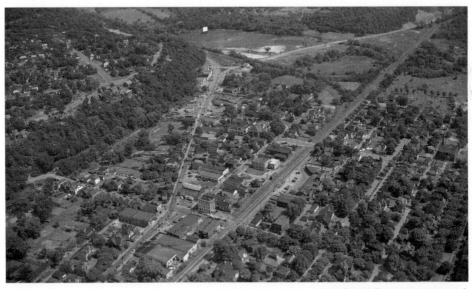

Credit: Valley News Dispatch

Here is how Parnassus looked from the air on Oct. 13, 1950. Note the Gateway Drive-in Theater in the upper center, which had just opened several months earlier.

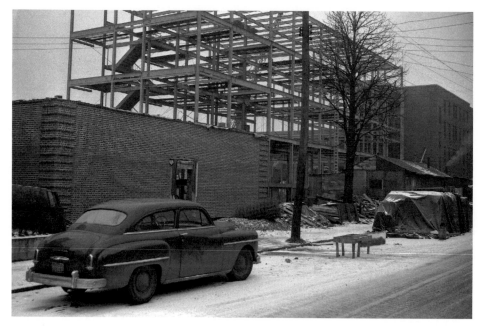

Credit: Valley News Dispatch

The addition to Citizens General Hospital was well underway in February of 1951.

Officials heralded the completion of the CGH addition on Oct. 7, 1952.
The expanded facility added 60 beds and 24 more bassinets to accommodate
the Baby Boom at the time.

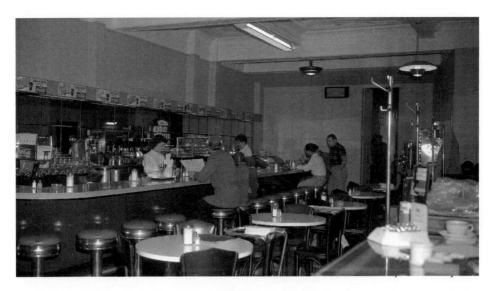

This is one of the quieter moments at the Kenmar Hotel on 5th Ave. It was a popular lunch time stop for many years.

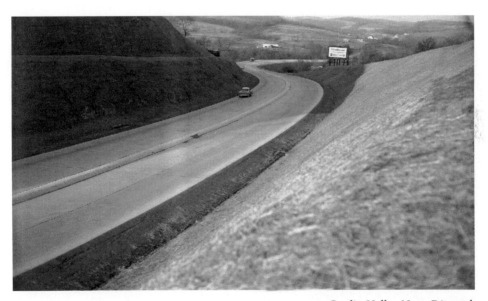

Cars on the left headed back to New Kensington on the Route 56 Bypass in Lower Burrell on Nov. 11, 1958. The area on the left is close to where Hillcrest Volkswagen is now located.

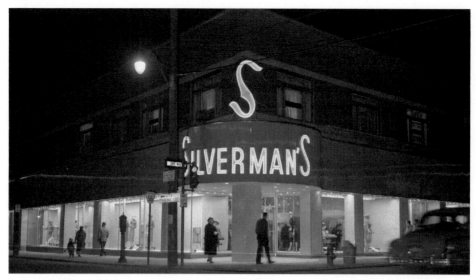

Credit: Valley News Dispatch

One of downtown New Kensington's most popular shopping places was Silverman's Department Store at the corner of 4th Ave. and 9th St. in this March 18, 1958 photo.

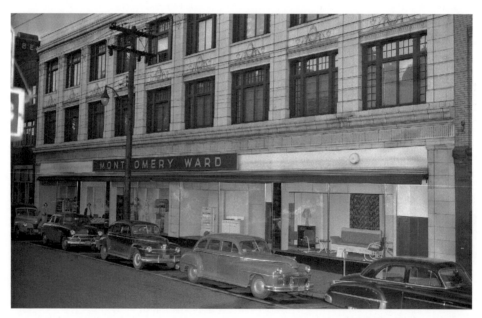

Credit: Valley News Dispatch

Montgomery Wards occupied a large area in the 1000 block of 5th Ave. before the store moved to Lower Burrell in 1971.

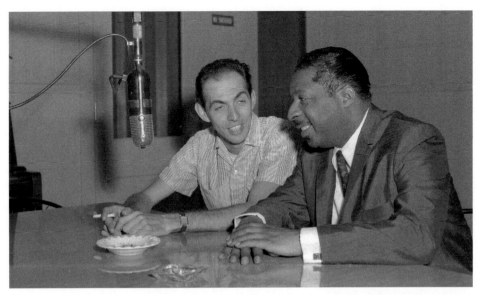

Jazz great and Pittsburgh native Errol Garner visits Phil Brooks at the
WKPA Radio studios at 810 5th Ave. on June 21, 1959. Garner was known as a top
jazz pianist in his time. WKPA went on the air in October, 1940. The 'K' stood
for Kensington and the 'PA' Pennsylvania.

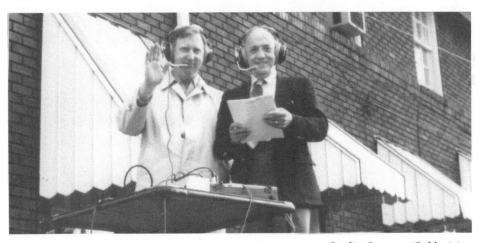

Bob Tatrn and Joe Falsetti lasted over 50 years as broadcast partners. The duo is pictured
here covering the NK10K road race from a platform set up on the 800 block of 4th Ave.
Their career together from 1965 until Falsetti's death in 2006 and spanned AM and FM
radio, cable television and even satellite broadcasts in the late 1980s. "We lasted longer
than most marriages," Falsetti sometimes quipped.

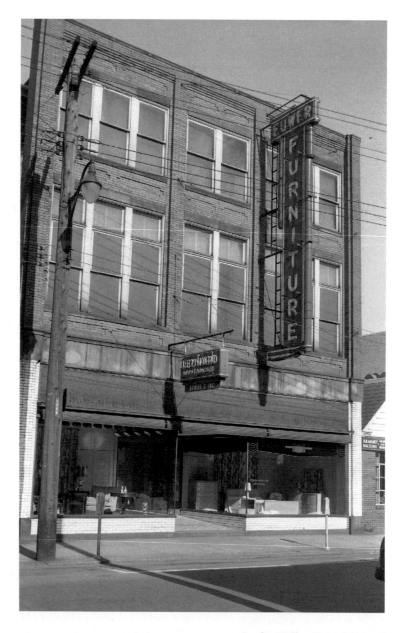

Credit: Valley News Dispatch

Euwer's Furniture Store was located on the 800 block of 5th Ave. where the alley still runs along the north side of the building.

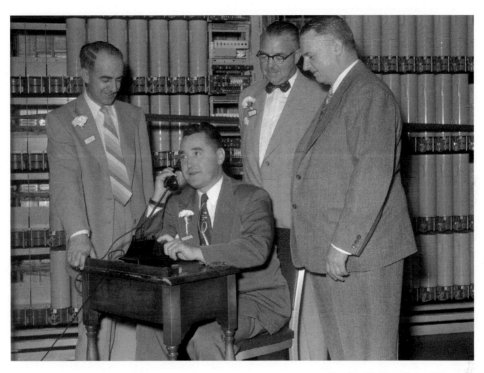

On June 22, 1952, telephone calling underwent a dramatic change. Each phone system had its own designated term where a caller would use the first two letters, then dial the remaining five digits. The New Kensington exchange had ED (33) for Edison. Tarentum's was AC (22) for Academy and Springdale's was BR (27) for Broad. Here, New Ken Mayor Raymond Gardlock makes the first Edison call to Arnold Mayor M. Frank Horne from the Bell Telephone building on the 1000 block of 5th Ave. Looking on are J.C. Longstreth, VP and General Manager of PA Bell, Fred Lyle of the New Kensington Chamber of Commerce, and Robert Stach, Bell Manager of Valley Exchanges.

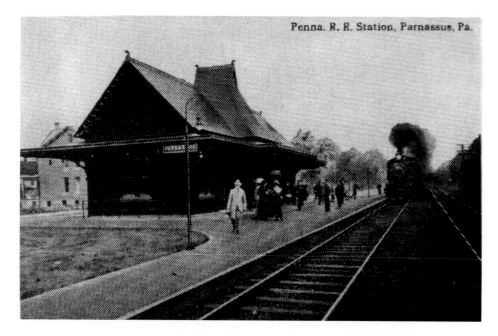

The Parnassus Railroad station picked up passengers until 1951.
It was located across the tracks from where the highrise is now.

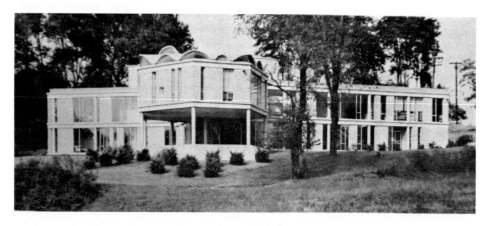

The Miners' Clinic along Powers Drive brought first-rate medical care to middle class
families who otherwise couldn't afford it.

The Bloser mansion was a mainstay along 6th Ave. in the Parnassus
section for many years.

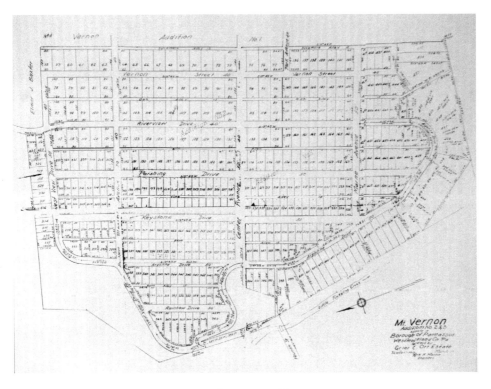

Here is a 1916 layout of streets and lots in Mount Vernon,
then part of Parnassus Borough.

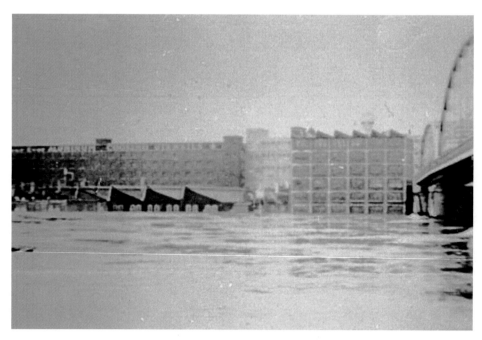

The Allegheny River rose toward the bottom of the 9th St. bridge on March 17, 1936.

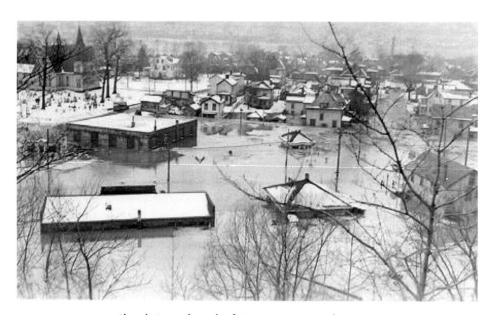

Church St. and much of Parnassus was underwater
from the St. Patrick's Day flood of 1936.

ALCOA AND NEW KENSINGTON

There is no doubt that New Kensington can be considered the cradle of the aluminum industry in America. From both the start of New Kensington and Alcoa, the lives and fortunes of both have been intertwined, directly and indirectly, for over 100 years.

In 1886, Charles Martin Hall, a young Ohio man, discovered the electrolytic smelting process to produce the metal economically.

The Pittsburgh Reduction Company got its start along Smallman Street in Pittsburgh's strip district. But the operation could only produce about 50 to 100 pounds of aluminum daily and a larger plant was needed. It was abandoned and moved to New Kensington in 1891.

Pittsburgh Reduction acquired a 3.5-acre tract from the Burrell Improvement Group along the town's riverfront. The New Kensington plant initially produced about 500 pounds per day and was increased to 1,000 pounds daily by 1893.

Aluminum production in New Kensington was stopped in 1896 when a larger plant was built in Niagara Falls, N.Y. to take advantage of cheaper electric power at that location. Alumina was still produced in New Kensington to supply the Niagara Falls plant, but that production was moved to a new plant in East St. Louis, Ill. in 1902.

Despite the removal of the metal production, the New Kensington Works continued to grow, concentrating on metal fabrication and manufacturing new products. By 1902, the plant property had expanded to 15 acres and buildings that used a total of 173,000 square feet. About 300 employees were engaged in making special alloys and ingots, castings, sheet, road and bar, wiring, rivets, tube, cooking utensils and job shop items.

The name was changed to the Aluminum Company of America in 1907.

In 1914, the cooking utensil business was moved to the Wear-Ever Building on 11th Street.

Commercial aluminum foil was produced starting in 1912 and demand for the popular product mandated expansion in 1916 and 1919.

Aluminum automobile trim production was started in 1906 and quickly became popular and a tube mill was later built in Arnold.

Aluminum bronze powder, finely flaked bits of aluminum, were used mainly as pigment in paints and inks. In 1918, land was purchased in the Logan's Ferry section of Plum Township and aluminum powder production was underway.

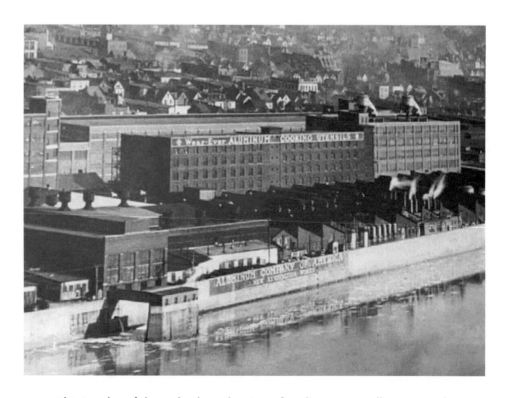

This is a shot of the early Alcoa plant just after the cement wall was erected.

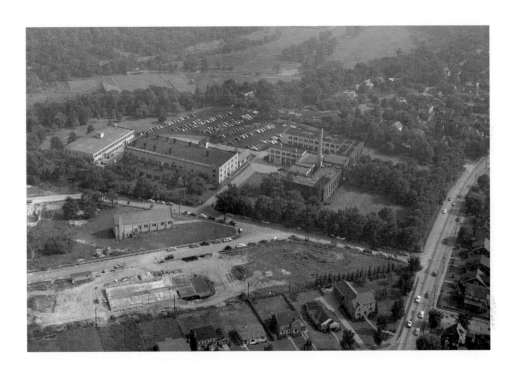

Here is an aerial photo of the old Alcoa Research plant along Freeport Road.
Note the Ken High football stadium in the background before the high school was built.

The New Kensington Works by this time had grown to about 75 acres and 3,000 employees.

For all intents and purposes, it was the headquarters of the U.S. aluminum industry.

The Aluminum Club, built on Freeport Road in 1918, provided a home for new technical and professional people getting established with the company.

The site was later used as a residence for Citizens General Hospital nursing students and is now The River Church.

ALCOA was one of the early companies to establish a research and development wing.

The research laboratory was located on Freeport Road in 1929, and operations continued there until 1970.

By 1940, 7,500 workers were employed by Alcoa in the area. It was truly "The Aluminum City."

The first chink in the Alcoa-New Kensington armor came in 1947 at the Industrial Day dinner when Roy Hunt, Alcoa's president, announced that some Wear-Ever production would be moved to a new plant in Chillicothe, Ohio. It would be the first of many moves that would eventually mark the end of the aluminum production manufacturing operations in the area.

The research and development operations became a bigger and bigger part of Alcoa. In 1957, the company acquired 2,300 acres of land in Upper Burrell Township. Part of the tract was flat land that had been set aside for a regional airport. Upper Burrell, however, couldn't find any other municipal partners to come aboard, and the airport plans were abandoned.

In 1962, ground was broken for the Alcoa Technical Center. The land mass stretched into the Camp Nancy area of Washington Township. That same year, Alcoa donated 35 acres of the tract to the Pennsylvania State University in order to move its branch campus from Parnassus to Upper Burrell.

Post-World War II production continued strong in Alcoa's manufacturing operations, with 82.8 million pounds of production in 1956. But by 1960, that figure had fallen to 33.8 million pounds.

In 1966, Alcoa workers voted 7-to-1 to accept a plan that would move some modern equipment from other Alcoa plants to New Kensington. But the move couldn't head off the eventual reality. In 1970, Alcoa announced it would end manufacturing operations in 1971, 80 years after the Pittsburgh Reduction Company moved to the new town of "Kensington."

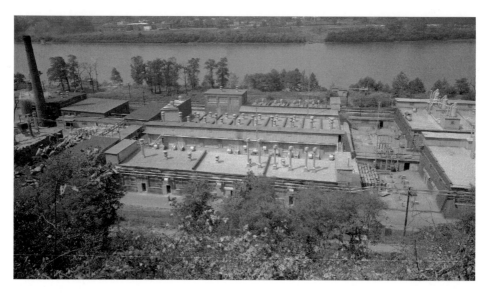

Credit: Valley News Dispatch

This November, 1958 photo shows the Alcoa powder plant that was located along the riverfront in the Logan's Ferry section of Plum.

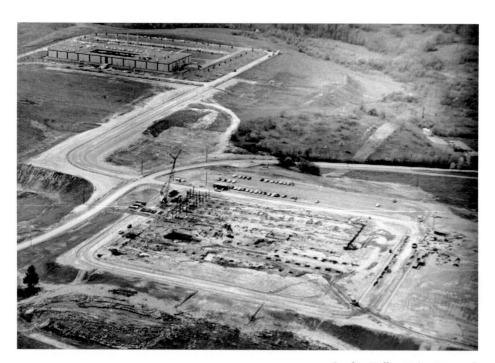

Credit: Valley News Dispatch

This aerial view shows the second building of the Alcoa Technical Center under construction in Upper Burrell in 1966.

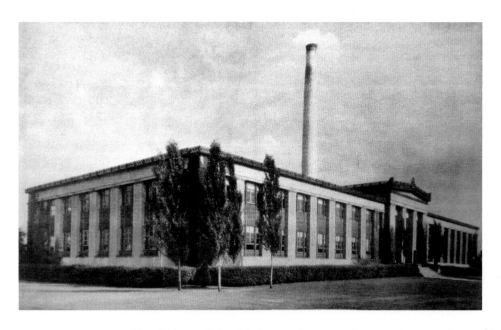

Here is a ground level photo of the old Alcoa Tech Center along Freeport Road

The Wear-Ever cooking utensil works was located on 4th Ave. and 11th St.
It is now an apartment complex.

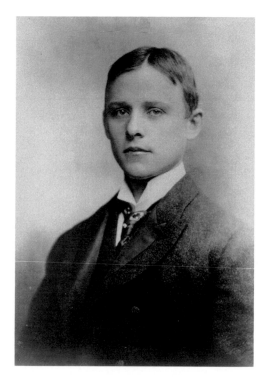

Though he looks young enough to be a junior high student, this is Charles Martin Hall, age 22, in 1886 when he received the patent for the reduction process that produced aluminum. Were it not for Hall, the history of New Kensington would be quite different.

Credit: Henry Holt Publishing

This is Alfred E. Hunt, president of the Pittsburgh Reduction Co., later to be known as Alcoa. The Hunt family had a long relationship with the aluminum industry that lasted several generations.

Credit: Henry Holt Publishing

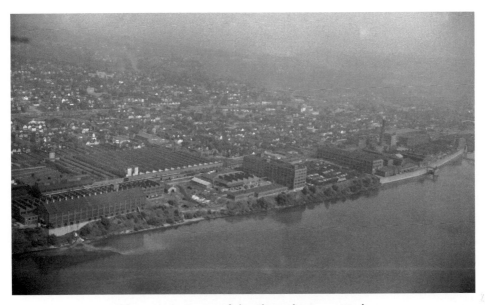

Here is a panorama of the Alcoa aluminum Works

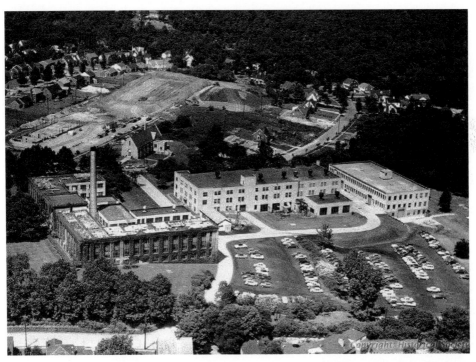

Credit: Valley News Dispatch

Here is a view of the Alcoa Research Center with the construction of the
Edgewood School taking place nearby.

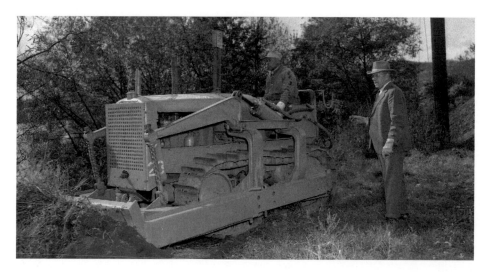

Credit: Valley News Dispatch

Ground was broken for the Tarentum Bridge on Oct. 24, 1949. There was no formal ceremony, no speeches, no pizzazz. Roy Dickerson of Coraopolis manned the bulldozer while J.H. Doll, superintendent of bridge construction at John F. Casey Co. looked on. Construction started on both sides of the Allegheny, with the parties eventually meeting at mid-river.

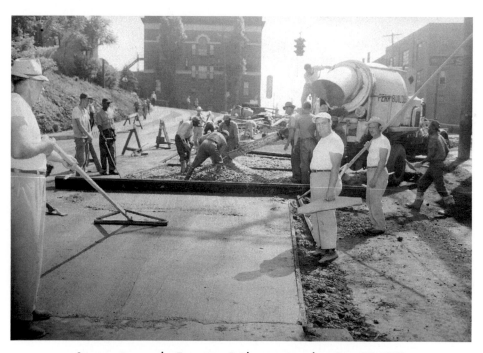

Construction on the Tarentum Bridge continued on June 11, 1951
with concrete pouring on the approach from West Tarentum.

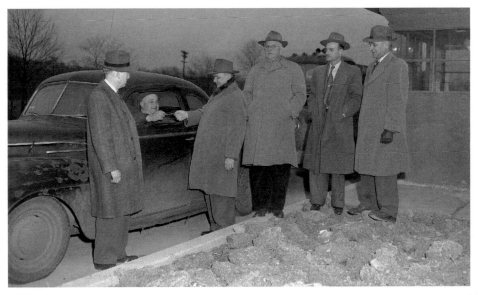

Credit: Valley News Dispatch

Angelo Frederick became the first driver to cross the newly-minted
Tarentum Bridge on Feb. 18, 1952.

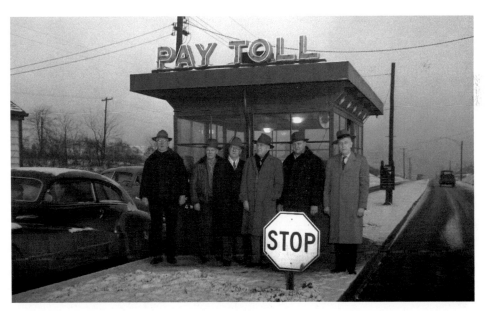

Credit: Valley News Dispatch

The Tarentum Bridge tolltakers gathered for a photo on Feb. 18, 1952

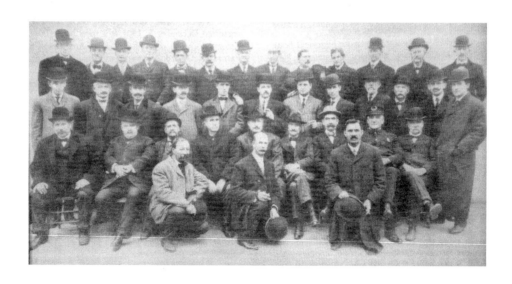

The New Kensington Board of Trade, forerunner of the Chamber of Commerce,
gathered for a 1906 photo.

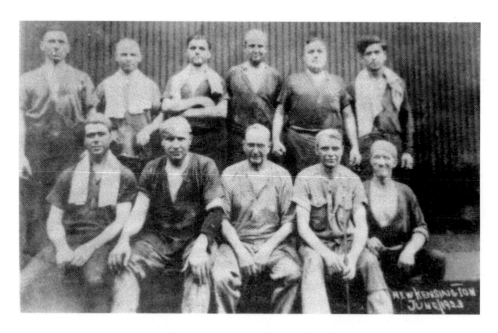

American Sheet & Tin Co. workers on break in 1923.

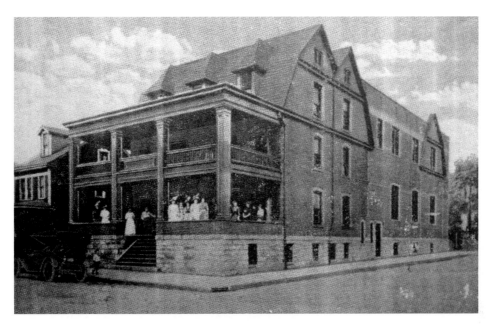

This is the original B.P.O.E. (Elks Club) building at the corner of 4th Ave. and 7th St.

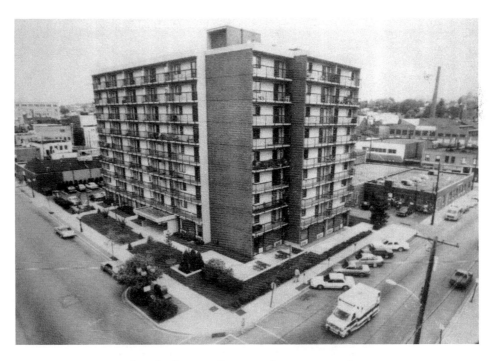

Today, the former Elks site is the Citizens High Rise

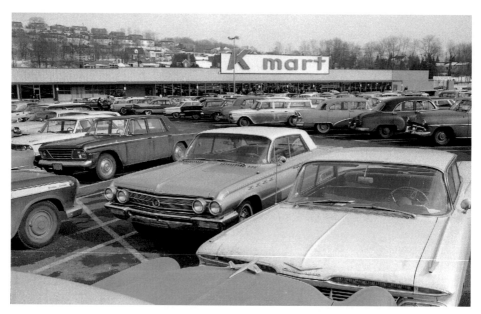

Credit: Valley News Dispatch

It is opening day at the K-Mart on Feb. 27, 1964.

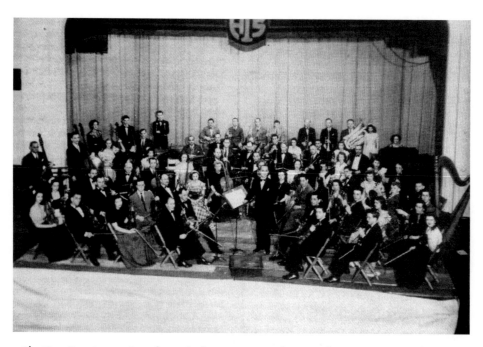

The New Kensington Symphony Orchestra gets ready to perform an evening of music.

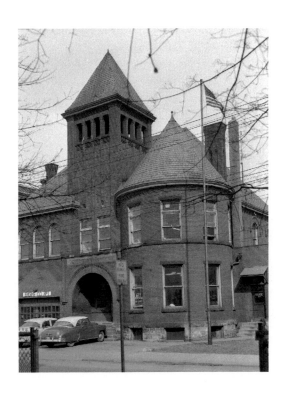

This is the original New Kensington
City Hall at the corner of 4th Ave.
and 11th St.

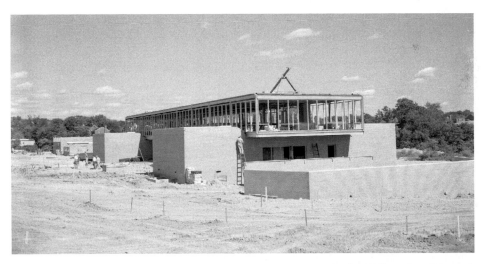

Credit: Valley News Dispatch

Workers continued construction at the new city hall location along
Leechburg Road in August of 1958.

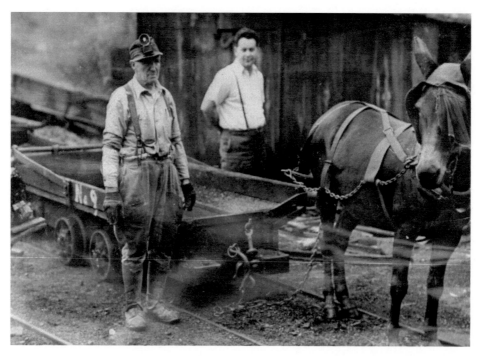

Credit: Alle-Kiski Heritage Museum

Two Valley Camp Coal Co. miners used a trustly mule to bring loads of coal
to the surface in 1939.

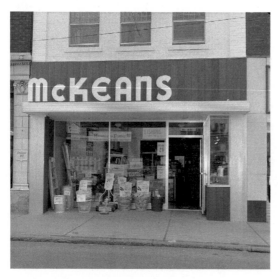

Here is McKean Hardware on
9th St. after remodeling was
completed on Sept. 19, 1960

Credit: Valley News Dispatch

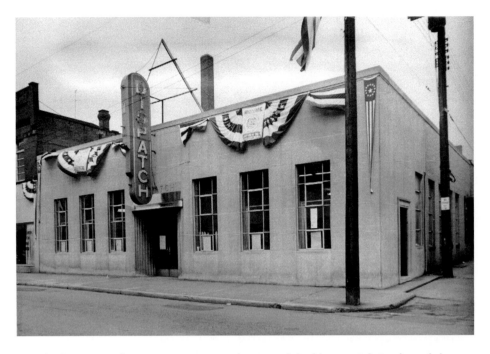

The bunting at the New Kensington Daily Dispatch building on 9th St. showed the newspaper was getting ready for the City's Diamond Jubilee in 1966.

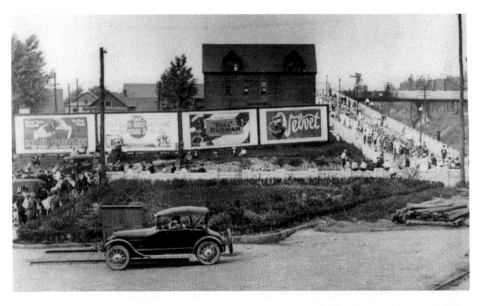

A parade comes across the Locust Street Viaduct. Note the billboards at the bottom of the bridge where the post office parking lot now exists.

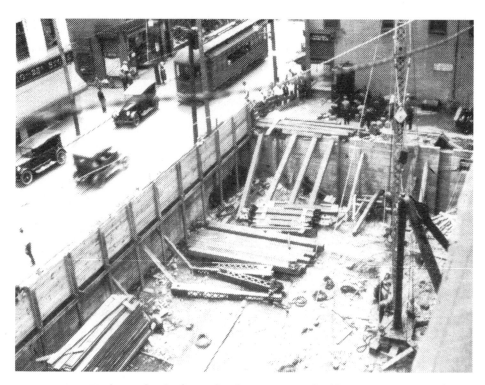

Workmen dig the footer for the Logan Trust building in 1925

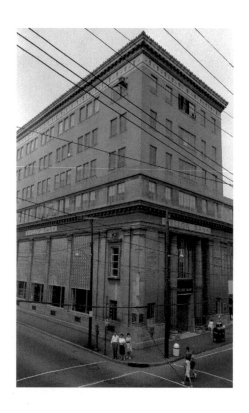

Here is a look at the Logan Building on
Aug. 4, 1962. For many years, it was the
tallest building in New Kensington

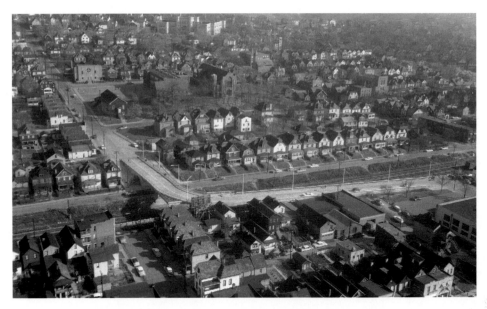

The new & improved Locust Street Viaduct opened in 1957.

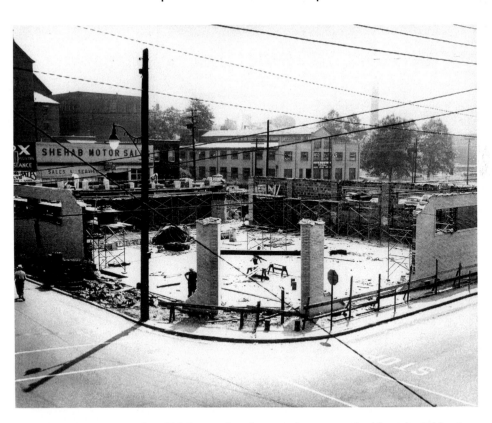

Construction continued at 880 Barnes St. where workmen were building the Loblaw's Super Market, later to become the home of the People's Library of New Kensington.

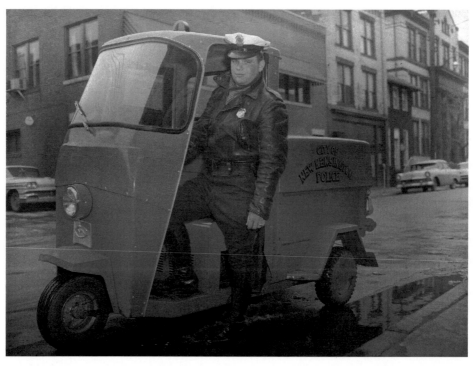

New Kensington police officer, Gene Grzybek, got around on a motorized scooter in 1960.

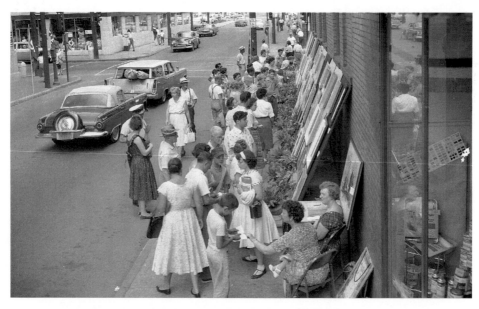

The New Kensington Art Show occupied portions of 9th Street in July of 1959.
It was an annual event sponsored by the Chamber of Commerce located
near Valley Art Shop, owned by Vincent Cascone.

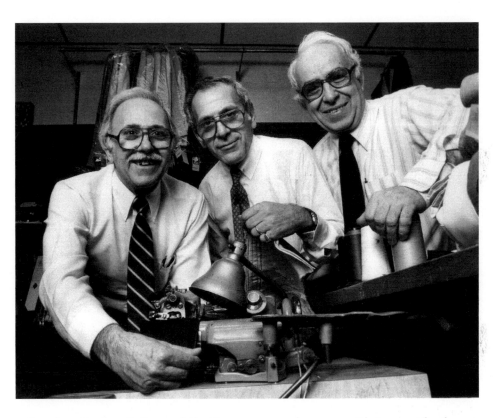

Bartolacci Brothers Tailors and Clothiers was a popular stop on 5th Avenue. The three brothers, Murphy, Gaspare and Guido, learned their craft in Italy. They expanded their business to include fine quality men's and women's ready-made apparel.

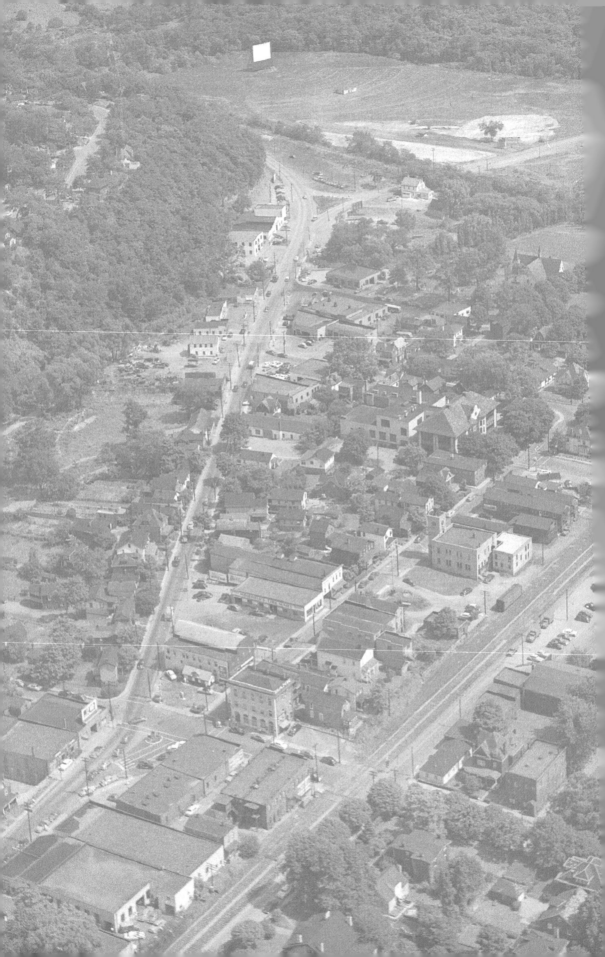

THE 40 ACRES CONTROVERSY

For nearly 90 years, Lower Burrell Township continued to lose hundreds of acres of land annexed first by Parnassus Borough, then by New Kensington.

But the 40 acres development was the last straw.

What's known as The 40 Acres is bordered by Craigdell Road, Richdale Drive, Edward Street and Elcor Drive. In 1954, New Kensington attempted to annex the development.

State officials told Lower Burrell the only way to stop New Kensington's annexation was to move from a township status to that of a Third Class City.

Two earlier tries at the ballot box earlier in the 1950s fell short.

But after the 40 acres annexation, Lower Burrell voters said enough was enough and voted in 1958 to jump to a Third Class City.

The move was too late to hold off the 40 acres annexation, however. It did create a strange mix where 40 acres residents were considered part of New Kensington, but 40 acres children attended the Burrell School District until 1966.

But then-New Kensington Mayor Raymond Gardlock had other plans. Gardlock dreamed of a consolidation of New Kensington, Arnold and Lower Burrell into one powerhouse municipality that would have had a population of about 45,000 at the time. The dream never got any traction.

Also in 1958, New Kensington's new city hall opened at the corner of Tarentum Bridge Road and Freeport Road. It would have been centrally located had the three cities merged.

New Kensington native Stephanie Kwolek with her invention of Kevlar.

STEPHANIE KWOLEK

Stephanie Louise Kwolek was born in New Kensington on July 31, 1923. She was a chemist and a pioneer in polymer research whose work yielded Kevlar, an ultrastrong and ultrathick material best known for its use in bulletproof vests.

Kwolek's father, a foundry worker, died when she was 10 years old, and her mother raised her and a brother alone. But her father passed on his love of science to her. In 1946, she received a bachelor's degree in chemistry from Carnegie Tech in Pittsburgh, now known as Carnegie-Mellon University.

Intending on eventually going to medical school, Kwolek went to work as a laboratory chemist in the rayon department at the DuPont Co. in Buffalo, N.Y. DuPont had introduced nylon just before World War II, and in the postwar years, the company resumed its dive into the highly-competitive market of synthetic fibers.

Kwolek moved with the company's Pioneering Research Lab in Wilmington, Del., in 1950. She worked with aramids, also known as a type of polymer that can be made into strong, stiff and flame resistant fibers that bore the trade name Nomex. Originally, Kwolek's assignment from DuPont in 1964 was to produce a texture that would allow tires to wear away more gradually in the event of a gasoline shortage.

She prepared the first-ever liquid crystal polymers that displayed unprecedented stiffness. The material was released commercially in 1971 with the name Kevlar, a fiber that finds use in high-strength tire cord, reinforced boat hulls and – of course – lightweight bulletproof vests.

Kwolek retired from DuPont in 1986 with the rank of research associate and accumulated a number of patents and awards during her career.

But the invention she is most proud of is Kevlar.

"I hope I'm saving lives. There are very few people in their careers that have the opportunity to do something to benefit mankind," Kwolek said to the American Chemists Society.

Stephanie Kwolek died on June 18, 2014 in Wilmington.

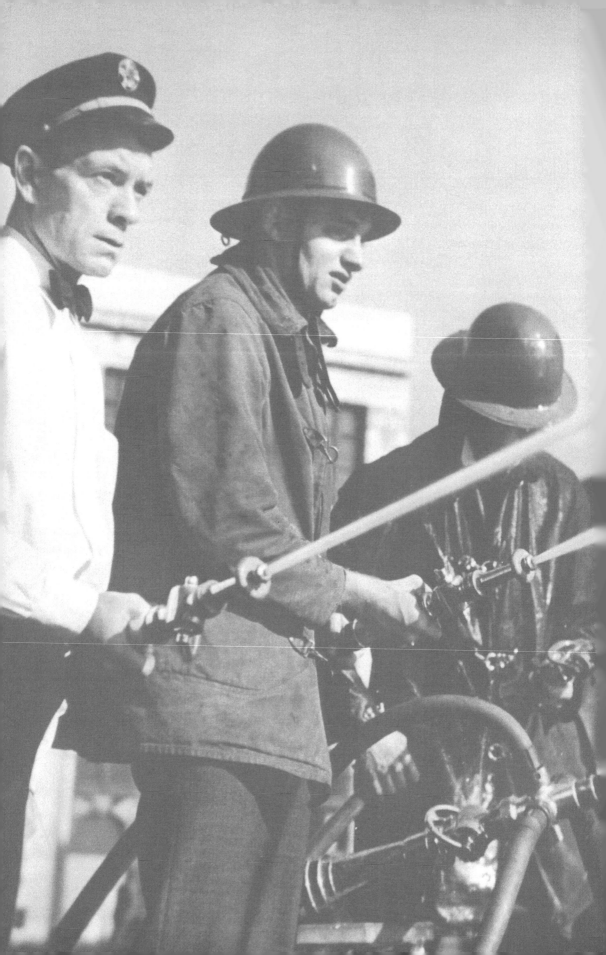

NEW KENSINGTON VOLUNTEER FIRE DEPARTMENT

The organizing of the New Kensington Volunteer Fire Department coincided with the founding of the city.

The need for a fire company became evident in 1891 when a bucket brigade extinguished a fire on the Rhodes property at the corner of 9th Street and Ivy Alley on Nov. 17, 1891.

Three days later, a meeting was called and the Citizens Volunteer Fire Company No. 1 was founded. The company secured a charter from the Westmoreland County Courts on April 23, 1892. The first fire chief was J. P. Mulvihill. For many years, firemen also worked at the Alcoa plant and management allowed firefighters to leave work and report to fire locations when necessary.

The new firefighting corps operated out of a small garage on Ivy Alley. The first piece of apparatus was a hose cart from the Kittanning Fire Dept.

The No.2 Fire Company was organized on Sept. 1, 1899 and was located on 7th Street near 3rd Avenue and moved into a new station in 1904 that was located in the upper part of 4th Avenue below 9th Street. This particular company served until 1915.

The present No. 2 company was organized in 1899 in Parnassus. When Parnassus and New Kensington merged in 1931, the station on Main Street became part of New Kensington's department.

The company was relocated in 1964 along Freeport Street in the Parnassus section of the city, about a block away.

Hilltop Hose Company, now known as No. 3, was organized on July 22, 1904 and was housed at the corner of Freeport Road and McCargo Street until 1911 when it moved to its present location on Victoria Avenue.

Company No. 4 was organized under the name of East New Kensington Volunteer Fire Department of Lower Burrell Township in 1926 and became part of the 1931 annexation. It is located along 7th Street near Strawn Avenue.

Company No. 5 was organized in 1924 and chartered in 1925 as the Valley Heights, Lower Burrell Township Volunteer Fire Department No. 2. When the new city hall was built in 1958 on Leechburg Road, the fire company relocated there. But when the City Hall was moved to 11th St. in 1991, the fire company left, too.

It is now housed on Camp Avenue near the water authority's reservoir and about a block away from its original location at the corner of Carl Ave. and George St.

Chief Ed Clawson served from 1918 until his retirement in 1960. His replacement, Genaur "Ike" Lemon, served from 1960 until 1978. Since then, Edward Saliba Sr. has been the fire chief. He will catch up to Clawson's tenure in the summer of 2016.

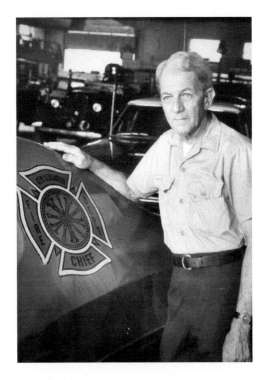

Genaur "Ike" Lemon served as chief from 1960-1978

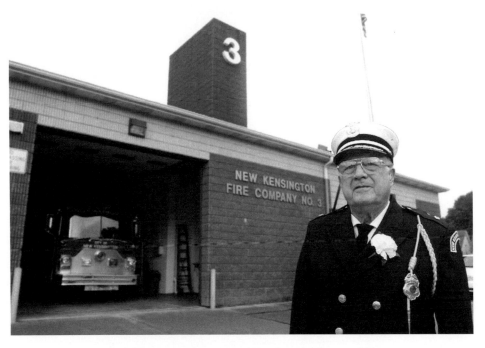

Chief Edward Saliba Sr. has been fire chief since 1978.

The New Kensington Fire Dept. had a humble beginning on Ivy Alley in the 1890s

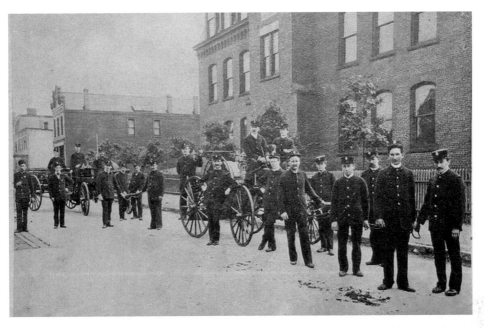

In 1910, firemen answered calls with carts and hoses, as portrayed here in front of the First Ward School.

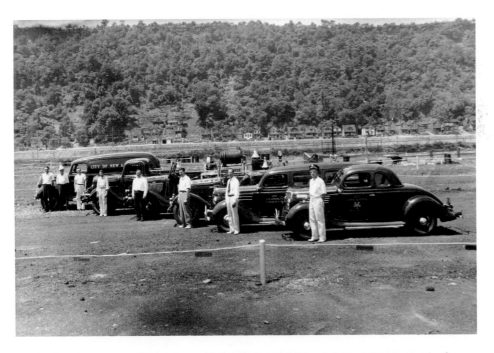

The fire department had a close relationship with Alcoa. In this 1937 photo, the fire company's fleet of vehicles were on display in Alcoa's parking lot. All of the firemen depicted were also Alcoa employees.

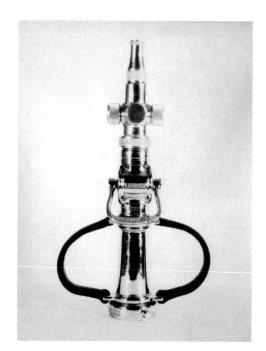

Fire Chief Ed Clawson received a patent for inventing the Clawson Nozzle in the 1930's. It allowed firefighters to hook hoses on to various parts of the device instead of being geared to one stream per nozzle.

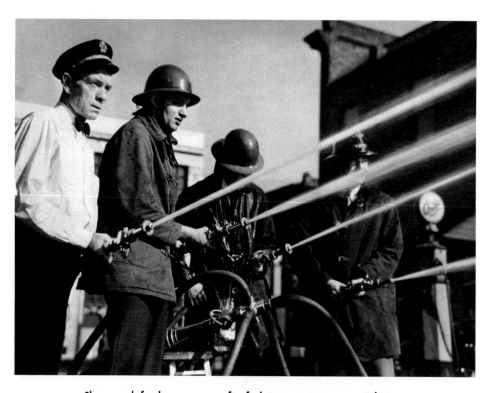

Clawson, left, demonstrates firefighting equipment on 5th Ave.

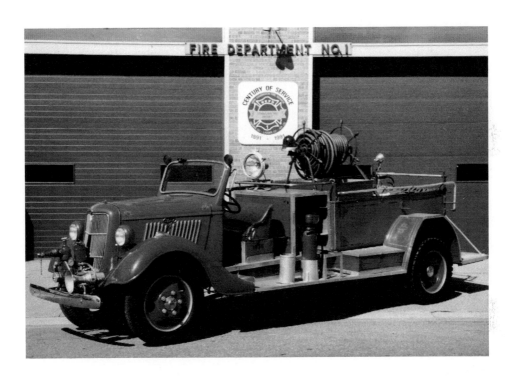

This 1935 vehicle had aluminum parts from Alcoa. It was in service until 1960.

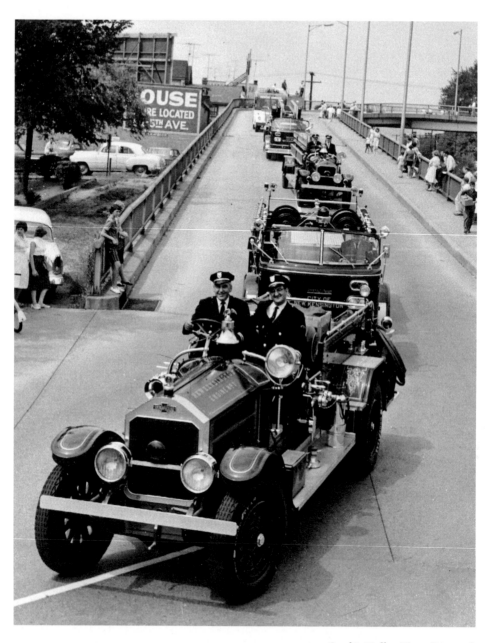

Credit: Valley News Dispatch

Firemen parade across the Locust St. Viaduct as part of the
1960 Western Pennsylvania Firemen's Convention.

This postcard depicts the corner of Victoria and Ridge avenues. The taller, building with the tower is No. 3 fire company.

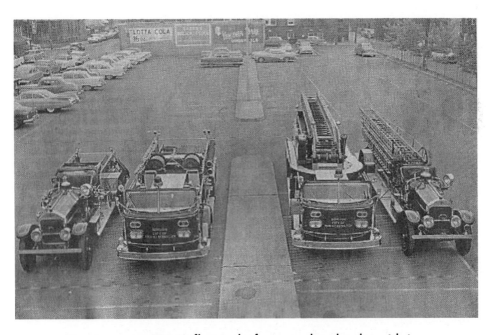

Here is company No. 1's fleet in the former parking lot along 4th Ave.
In the background is the original Eazer's Restaurant, now located at the corner of 5th Ave.
and 7th St. The soft drink advertisements on the rear wall of Eazer's were
all bottled at Lombardo's City Bottling in Arnold.

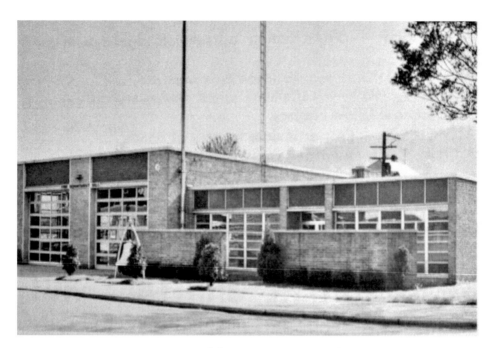

Here is a view of the No. I company on 4th Ave.

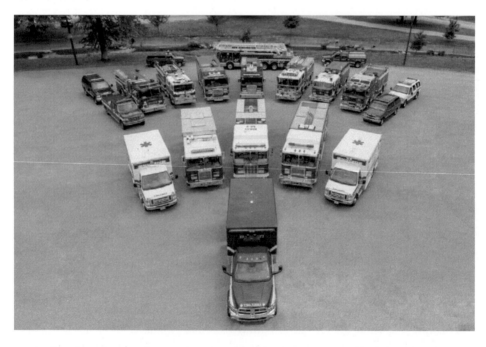

The fire department's fleet gathers in the parking lot at Valley High School in 2015.

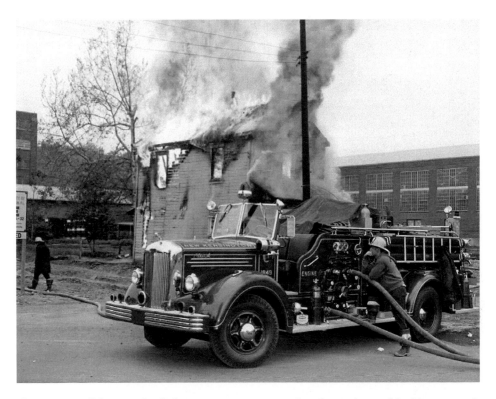

This isn't a real fire. It's firefighters practicing on an already-condemned building on 12th St. that was slated to be demolished with urban redevelopment on its way.

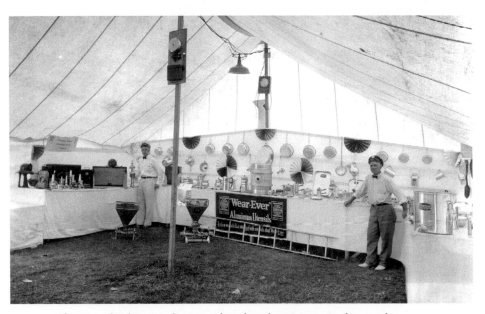

A fireman displays products produced at the Wear-Ever plant under a tent during a firemen's convention in Mount Pleasant.

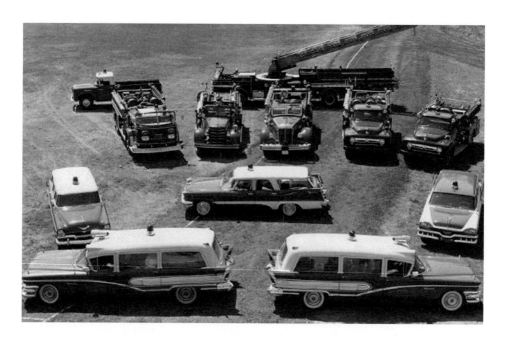

The Bureau of Fire's Vehicle Fleet was on display in 1963.

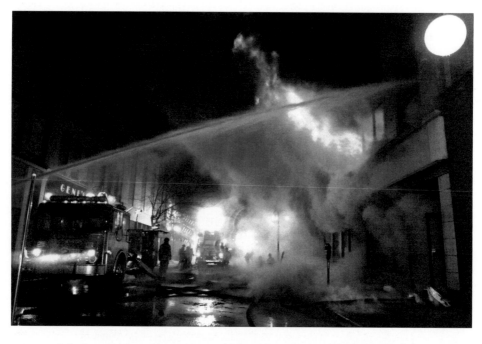

One of the biggest fires in New Kensington history destroyed the Pittsburgh Beauty Academy location in the 800 block of 5th Ave. in 2006.

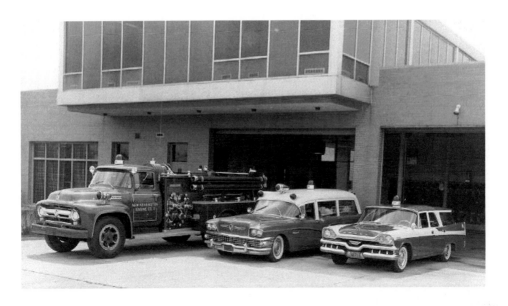

This is the old No. 5 fire station when it was located at the New Kensington Municipal
Building along Leechburg Road in 1958.

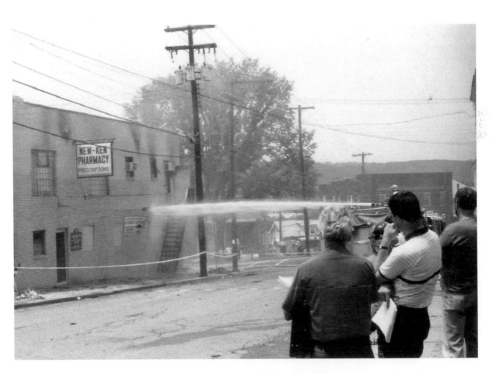

This is the aftermath of the New Ken Pharmacy fire at the corner of
Locust St. and Ridge Ave. in 1988.

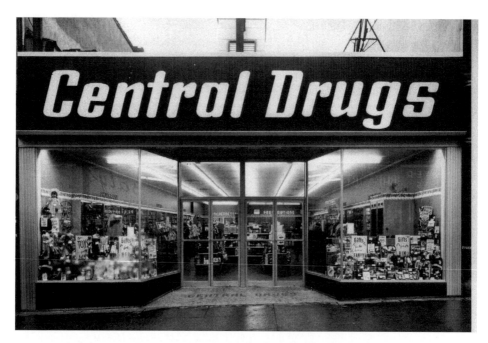

Central Drugs on Barnes St. was a popular location for many years until.........

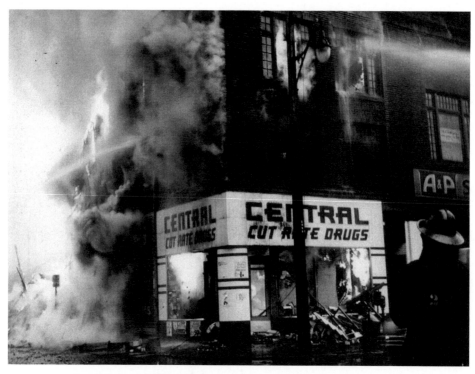

......fire destroyed the building, paving the way for the Loblaw's Market
and later the People's Library.

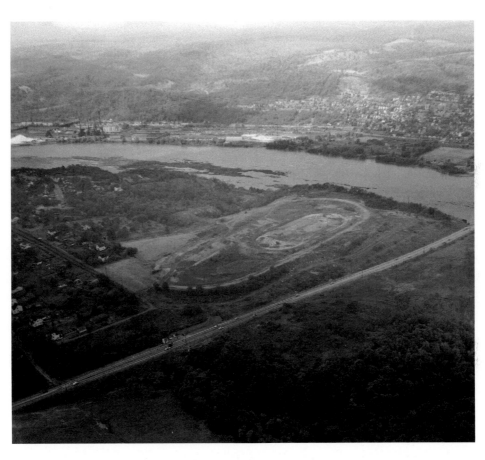

Shortly after the Valley Heights Race Track burned down in 1952, Ryan Homes began building homes in the Rivercrest plan.

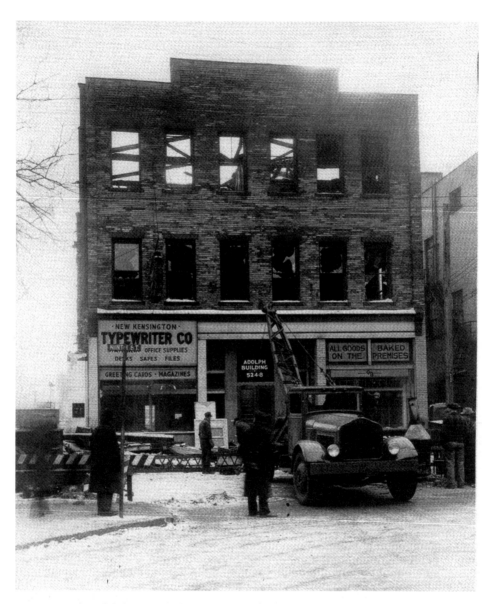

The Adolph Building fire destroyed several businesses on Barnes St.

EDUCATION

Formal education in New Kensington began when the first school building was constructed on Barnes Street.

Since the area was still part of Lower Burrell Township in 1879, the township supervisors recommended that the school be built.

One room schoolhouses included the Valley Camp and Martin schools.

The New Kensington School District came on the scene in April, 1893 after the first Board of Directors was formed in February of that year. Immediate construction of the First Ward School, then a four-room structure, took place.

Rapid growth of the town necessitated building the Leishman Avenue School, but it was sold to Arnold when it became a municipality in 1896.

Some classes were held in rented church rooms and the town hall, leading up to the opening of the Third Ward School in 1897.

In the fall of 1899, the first high school class of 12 students was registered. Of the original 12, six graduated in 1901. The courses were designed for a two-year high school program, instead of the more traditional three-year program.

New Kensington went to a three-year program starting with the 1904-05 school year.

The first high school building was on Fourth Avenue and it was completed in 1907. The building was converted to an elementary school in 1913 when the new high school was built along Ridge Avenue. The enrollment for that first academic year was 149. A vocational school and home economics were added in 1915.

By the early 1920s, the student body had grown to the point that a new classroom wing was added to the Ridge Avenue school. The gymnasium was also added as part of the expansion program.

The school district expanded quickly, particularly in 1931 when New Kensington and Parnassus consolidated and parts of Lower Burrell Township were annexed.

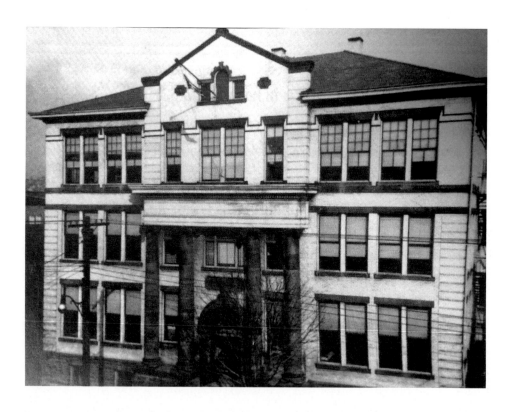

This is the first New Kensington High School on 4th Ave.

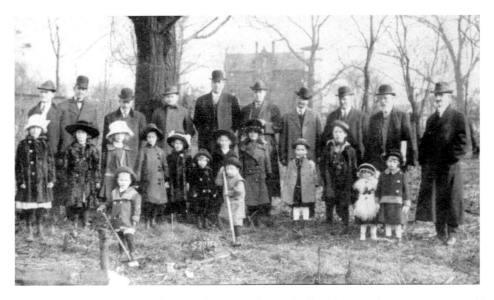

Future students took part in the groundbreaking at the
Ridge Ave. high school site in 1913

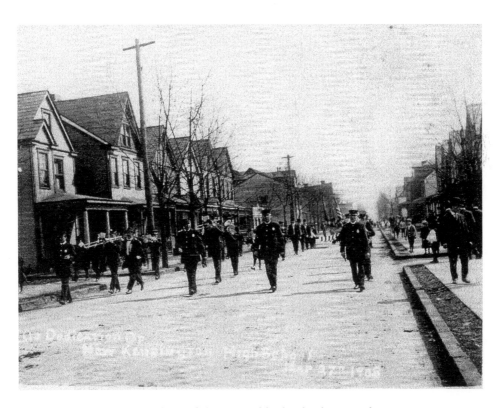

A band plays in front of the original high school on March 27, 1908.

After World War II, school construction boomed in New Kensington. Edgewood, Greenwald and Terrace elementary schools were opened. The school district renovated Fort Crawford, Mount Vernon, Martin and Walnut elementary schools.

In 1957, a $3 million high school was built on Stevenson Boulevard. It could house up to 1,400 students. Students from Lower and Upper Burrell attended high school in New Kensington, because Burrell High School wasn't built until 1964.

Soon after the high school opened, there was pressure from the state to merge the nearly 2,277 municipal school districts. Up to that time, nearly every municipality had its own school district. Cities like New Kensington and Arnold had separate public school districts that culminated with one's high school years.

Neighboring Lower and Upper Burrell each had its own school district, but did not sponsor a high school. In those cases, students attended high school in another community on a tuition basis. Most students from those municipalities attended New Kensington High School, popularly known as Ken High, or, by the contraction "Ken-Hi."

With state education officials bearing down on communities to merge their school districts, the communities looked at various consolidations.

In what now looks to be a bizarre proposal, 1958 saw New Kensington and Upper Burrell officials look at combining the two school districts, while Arnold and Lower Burrell would combine forces to form another school system.

On Oct, 14, 1958, upon the recommendation of Westmoreland County officials, Arnold and Lower Burrell agreed to discuss consolidation. At the time, each Pennsylvania county had a superintendent and each individual school district was led by a supervising principal.

Arnold and Lower Burrell agreed to meet on Nov. 10, 1958 at the Roy A. Hunt high school building in Arnold. A later get-together was held at Glade View Elementary School in Lower Burrell on Dec. 11.

The move eventually fizzled and the more logical conclusion was to merge the communities with contiguous, geographical borders. State Act 161 of 1961 attempted to reduce the number of state school districts from 2,277 to about a fourth of that total.

The all-time high for state school districts was 2,599 in the 1909-10 school year. By the 1979-80 term, the state had 505 school districts.

On July 1, 1965, the New Kensington and Arnold school districts were united with 5,900 students under the new umbrella.

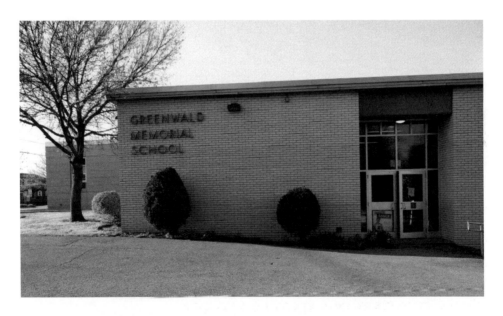

The Greenwald Elementary School was named after Navy Seaman 1st Class Robert D. Greenwald, who was killed in the Japanese attack on Pearl Harbor Dec. 7, 1941. He was age 20 and grew up on Camp Avenue. The 1950 building will become the Mary Queen of Apostles School in September, 2016.

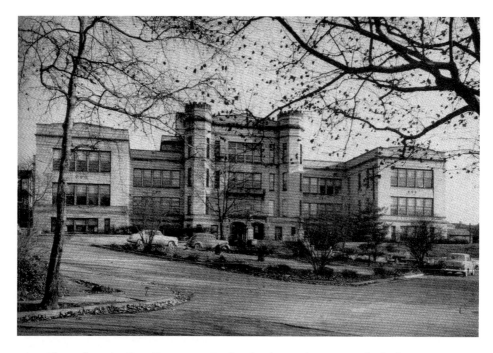

This is how the New Kensington High School on Ridge Avenue looked in 1950.

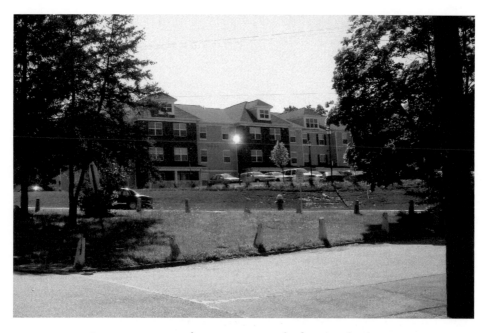

An apartment complex now occupies the former school site.

The eventual plan was to house all high school students in one building. Over the next two years, it was well known that the high school would be merged, but nobody really knew when.

By the time May of 1967 arrived, athletes from New Kensington and Arnold had a joint awards banquet for the first time. The handwriting was on the wall. Ken High and Arnold were on the verge of consolidation.

Soon into the summer, the New Kensington-Arnold School Board decided to have one high school. But Ken High was bursting at the seams already because students at the time were part of the early "Baby Boomers," – that is, those born between 1946-64.

The easiest course of action was to operate the two high schools under one name.

In August of 1967, football players, band members, majorettes and others were away at camp several weeks before the school year began. They performed under the unofficial name of the New Ken-Arnold Spartans.

When the school year got underway, a contest was held to name the new school. Valley High was the top vote-getter, outpacing other suggestions such as Ar-Ken High School and Northmoreland High School.

The new school would be called the Vikings and the colors would be black & gold.

For three school years, the former Ken High building was known as the New Kensington Campus of Valley High School and the Roy A. Hunt building was the Arnold Campus of Valley High School.

After an expansion project was completed, all high school students were housed in the New Kensington building. The Ridge Avenue school remained a junior high, likewise the Hunt building.

In 1983, Ridge Avenue closed its doors for the final time. Students were transferred to Arnold and it was rechristened Valley Middle School.

Further decline of student population by 2014 brought all students grades 7 through 12 to the Valley Junior-Senior High School.

The last Class President for Ken High in 1966-67 was William Holt Binger.

The first Class President for Valley High School in the 1967-68
school year was Wesley George Gardner.

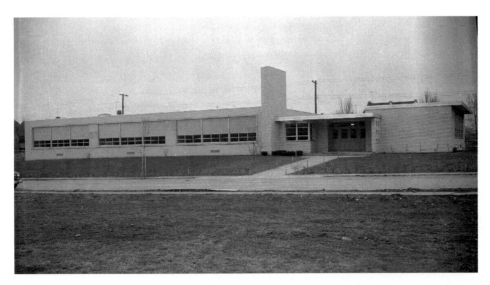

Credit: Valley News Dispatch

Here is a look at the Edgewood School on Nov. 25, 1953, shortly after it opened.

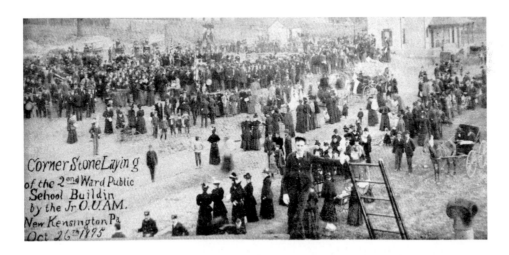

The Second Ward Public School groundbreaking celebration took place in 1895.

Driver's education came to New Kensington High School in 1948. Teacher Ken Slosky instructs a student and hopes he doesn't back into the fire hydrant.

This is the Vocational School located at the corner of Stevenson Blvd. and Powers Dr. A staffing service now occupies the site.

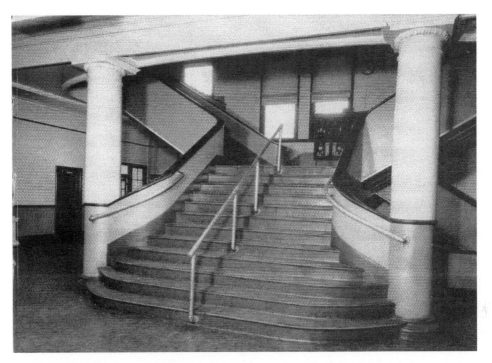

This is the staircase that greeted Ridge avenue high school students as they entered the building for another day of classes.

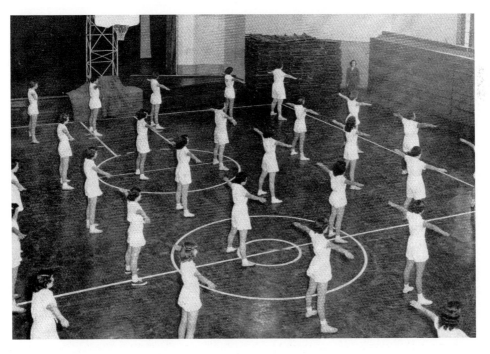

Instructor Miss Pascaretta keeps a watchful eye on her gym class in this 1950 photo.

Here is a photo of New Kensington High School's first graduating class in 1901.

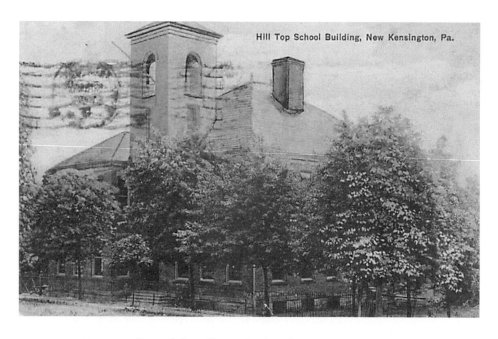

Hill Top School Building, New Kensington, Pa.

Here is a photo of the Hilltop School in the Victoria Avenue area.

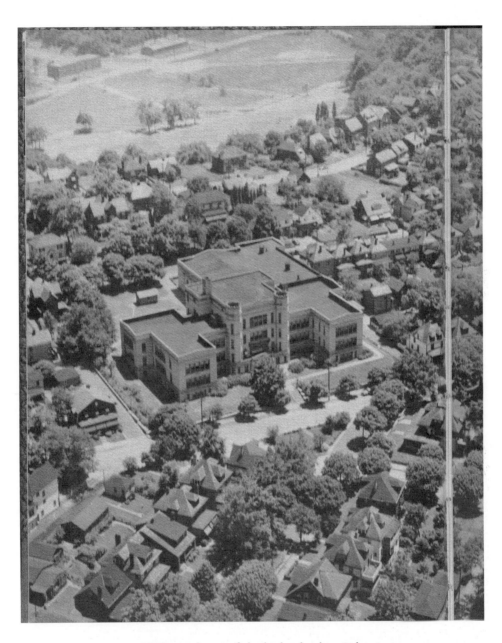

Here is a 1950 aerial view of the high school on Ridge Avenue.
Note in the background the New Kensington City garage that still stands.

Credit: Valley News Dispatch

The 7th St. bridge and the access road to the new high school building was temporarily halted due to bad weather on April 19, 1957

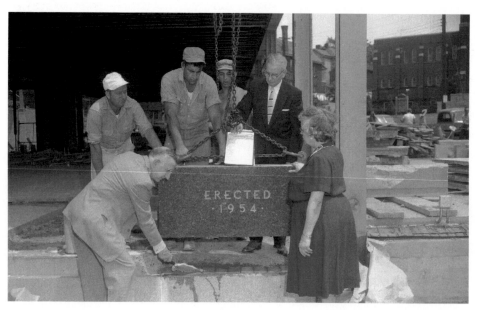

Credit: Valley News Dispatch

The cornerstone for the new YMCA building was laid on June 15, 1954.

Here is how the new YMCA looked on opening day, June 11, 1955

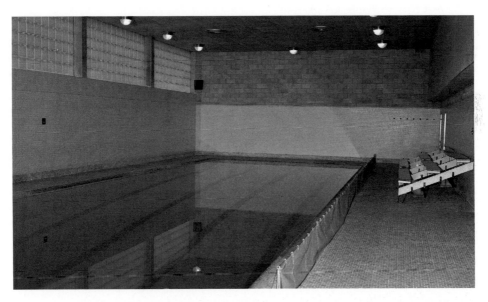

The swimming pool was filled for the first time at the YMCA on June 11, 1955

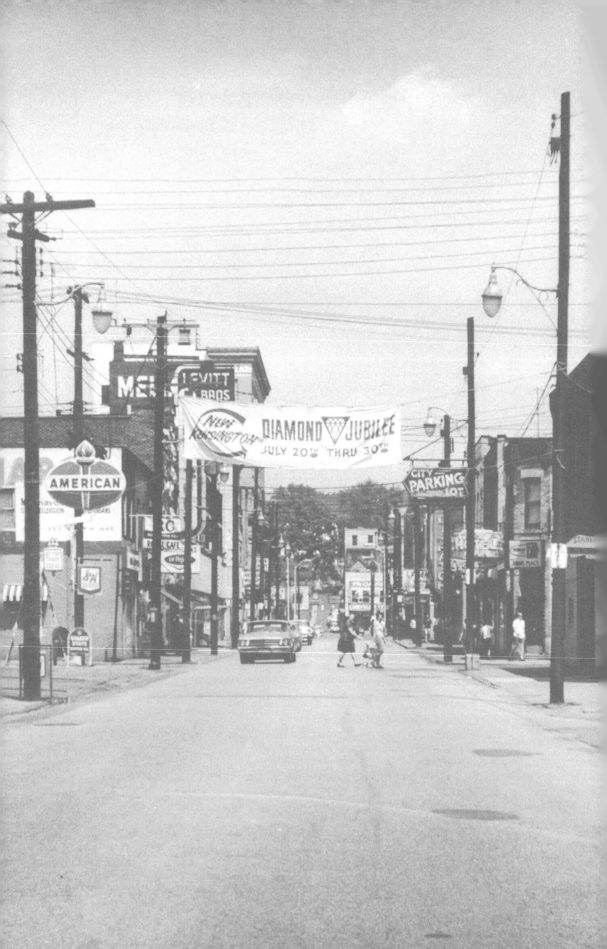

BURRELL CONSTRUCTION

On Jan. 30, 1915, J.S. Murray of the J.S. Murray Co. (a sidewalk construction company based in Arnold) got together with George M. Evans, a local oil and gas entrepreneur and formed State Construction Co.

State Construction bought the property of the Phoenix Pottery Co. located at 3rd Ave. and 5th St. in Parnassus, about half a city block in size. The Company owned four dump trucks.

On Spet. 25, 1928, Mr. Charles H. Booth began his association with the company while on a 6-month leave of absence from American Sheet & Tin Plate Co. of New Kensington. In 1929, George M. Evans was "pushed out" and J.S. Murray was made company chairman of State Construction

At the height of the Great Depression in 1931, Logan National Bank of New Kensington took control of the company and installed Charles H. Booth as General Manager. On May 29, 1935, a fire of undetermined origin destroyed the main plant and the majority of the equipment.

The Burrell Construction & Supply Co. was founded shortly thereafter on July 10, 1935 with F.J. King serving as President and C.H. Booth Vice President and General Manager.

Charles H. Booth Jr. began his long association with the company as a laborer during vacation time from high school and college until he enlisted in the U.S. Army Air Force as a flying cadet and served four years on active duty during World War II. He later served in the USAF Reserves, retiring as a Colonel in 1979.

The company began to aquire pieces of construction equipment and was soon a leader in the field with one plant and five employees, growing to 12 plants , 500-600 employees, 500 pieces of equipment and sales of $46 million.

F.J. King died of a heart attack on August 23, 1948 and C.H. Booth assumed the presidency. His widow, Elizabeth King, sold her inherited shares to

Charles Booth Jr. The Booths and H.B. King owned the comapny on a 50/50 split of shares.

Mr. C.H. Booth Sr. died of a stroke on Sept. 4, 1972 and Mr. C.H. Booth Jr. became president. Burrell Construction & Supply changed its name to the Burrell Group, Inc. in 1988 and purchased the New Kensington Municipal Building in 1990. Burrell Construction & Supply bought the Ben F. Evans Insurance Co., which became Westmoreland Insurance Services. Over the years, other companies incorporated included Burrell Industrial Supply, Standard Terminals, Burrell Construction and Supply of Utah and Continental Development, owning various land and plant sites, including Indian Fields I and II in Lower Burrell.

Credit: Valley News Dispatch

Burrell Construction was a vital city industry for many years. This is an overview of the plant on Sept. 5, 1957. Note the baseball diamond at nearby Herr Stadium and the new Stevenson Boulevard winding its way in the upper part of the photo.

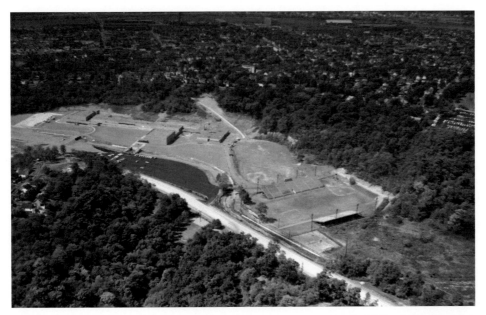

This is an overhead view of Ken High on Aug. 31, 1957. Note the baseball diamond where the Career & Technology School now stands and Cook's Path, a easy route connecting the high school with Charles Ave.

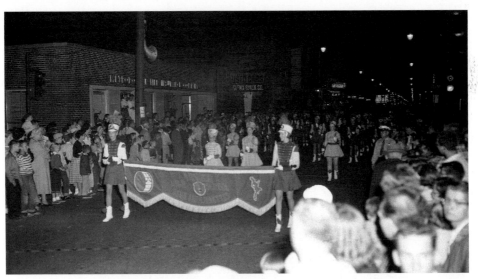

The Fort Crawford Day parade marches through the intersection of 5th Ave. and 7th St. on Sept. 10, 1957. The Arnold High band and majorettes make their way toward Paranassus. An estimated 35,000 people lined the parade route.

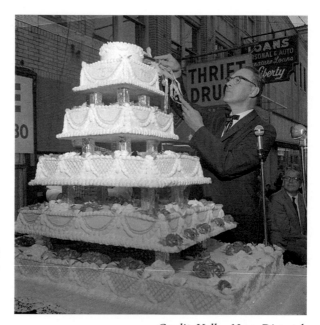

New Kensington Mayor Lenus "Hersh" Hileman gets ready to cut a gigantic commemorative birthday cake baked by Princess Pastries for the City's Diamond Jubilee on June 4, 1966.

Credit: Valley News Dispatch

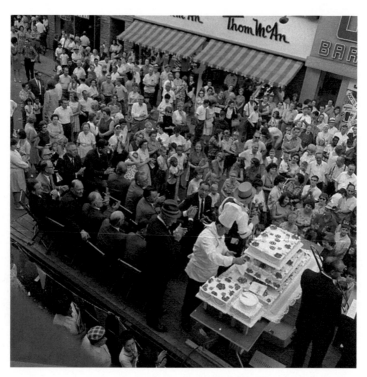

Credit: Valley News Dispatch

Here is an overhead view of the crowd gathered along the 800 block of 5th Ave. for the gala.

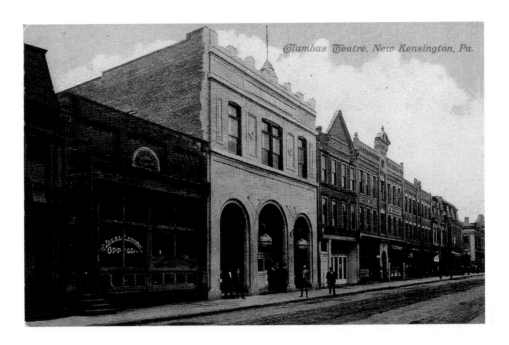

The old Columbus Theater along 5th Ave. was an early 20th Century entertainment spot.

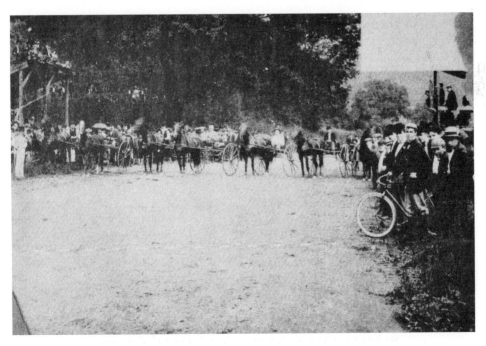

Harness racing was popular in Parnassus in the early 1900s

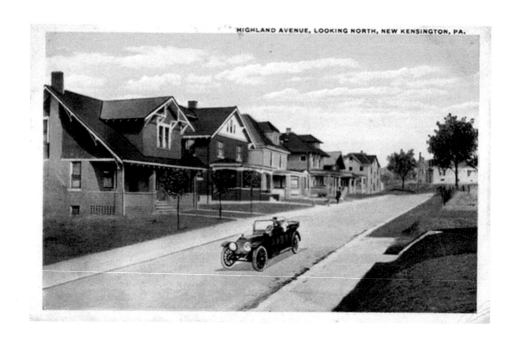

This postcard depicts Highland Ave. in the McKean Plan around 1917.

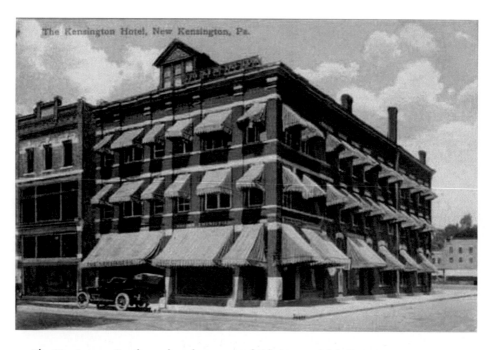

The Kensington Hotel stood at the corner of 5th Ave. and 9th St. It was a Sun Drugs location for many years.

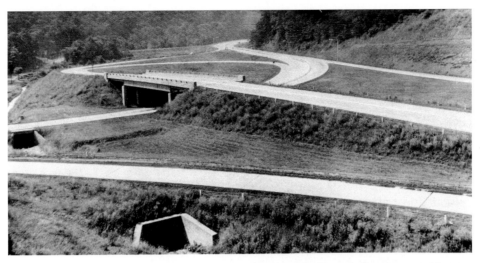

Credit: Allegheny Valley Heritage Museum

Fresh ribbons of concrete herald the opening of the Route 56 bypass
cloverleaf on June 12, 1955.

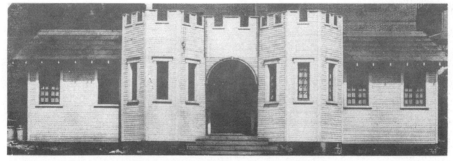

The American Legion Hut — The First Library

Built shortly after World War I, this building was located to the rear of the now vacant lot
near the middle of the 800 block of Constitution Boulevard. After being vacated by the Library
in 1930, the "Hut" served as a meeting place for several community organizations until it was
destroyed by fire in 1965. It is interesting to note that the city's first two-room jail house stood
on the same site during the early days of the city.

The American Legion hut in the 800 block of Constitution Blvd.
also served as the City's first library.

The Logan House was also the original Citizens General Hospital in 1914.

Before cars and trucks were popularized, Keystone Dairy, located along 6th Ave. in Parnassus, delivered milk by horse and buggy.

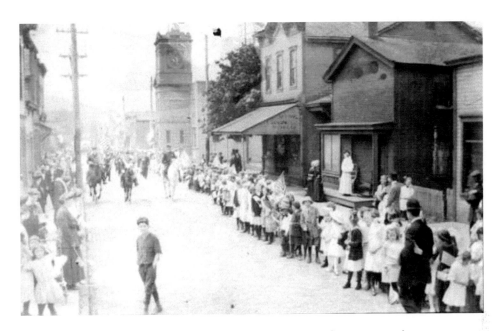

Horsemen ride through Main St. in Parnassus during a parade.

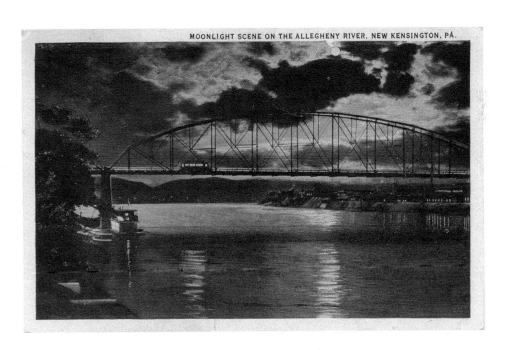

Moon over New Ken. A postcard depicts a moonlit night over the Bouquet Bridge.

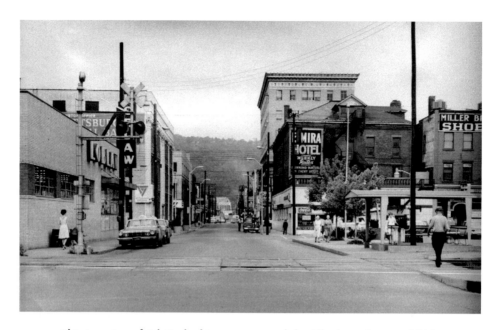

This is a view of 9th St. looking west toward the Allegheny River in 1966.

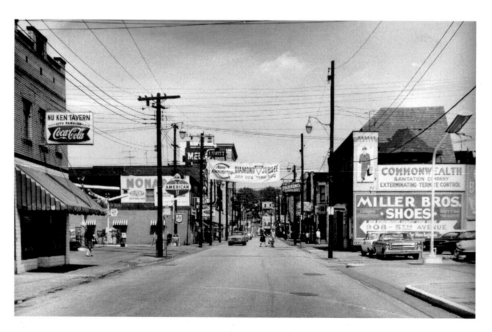

This is a view of 9th St. looking east in 1966.

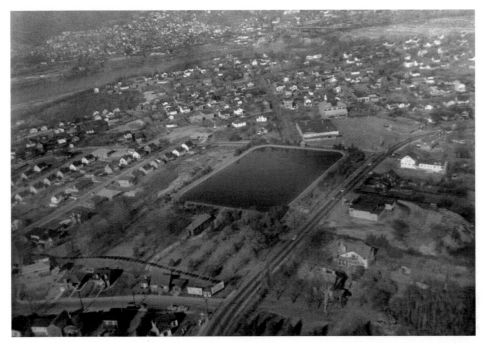

Credit: Valley News Dispatch

This is an aerial view of the New Kensington Water Authority's reservoir
in Valley Heights on Nov. 11, 1957.

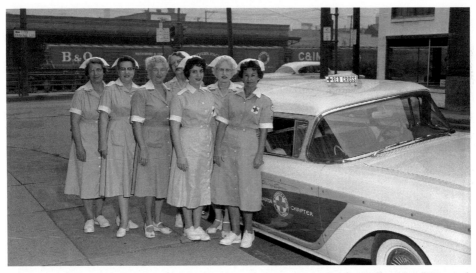

Credit: Valley News Dispatch

The New Kensington Red Cross opened its new station at the corner of Constitution Blvd. and
McCargo Street on July 22, 1959. Pictured from left: Mrs. Harry Ely, Mrs. Dale Henry, Mrs.
Fred Fischer, Mrs. Robert H. Love, Emma Shaffer, Mrs. E.J. Hockendanner and Mary Rucci.

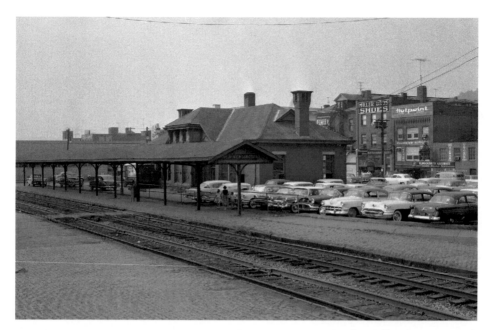

Credit: Valley News Dispatch

Here is the New Kensington Railroad station on July 31, 1957

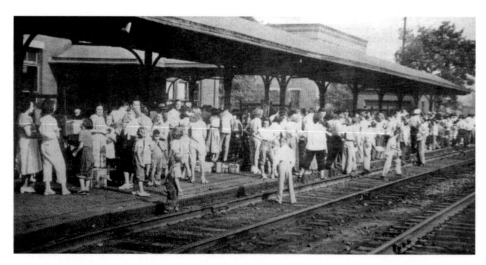

Students prepared to ride the rails to Kennywood Park in June of 1949.

CHURCHES

Mount St. Peter Church

In the estimation of many, the city's most well-known church is Mount St. Peter Roman Catholic Church. Its large membership, the location on a knoll looking over parts of the city and the inclusion of portions of the former Andrew B. Mellon mansion in Pittsburgh make the church grounds and building unique.

The church has received architectural awards and has been the subject of TV documentaries.

Monsignor Nicola Fusco, perhaps the most well-known religious figure in Alle-Kiski Valley history, served at the church from 1923-69.

The original St. Peter Church was organized by the Rev. Bonaventure Piscopo of the Apostalae Band for the Pittsburgh Diocese in 1902. Beginning in 1903, the newly-formed parish held its worship services for a short period of time in a stone room around the corner of 2nd Avenue and 10th Street under the guidance of its first resident pastor, Vincent Maselli.

Starting Sept, 28, 1903, the congregation moved to the basement of the St. Mary's Polish Church on Kenneth Ave. Shortly thereafter, the Burrell Improvement Group donated land at the corner of Constitution Blvd. and Ridge Ave. for a permanent church.

The early days of the church were tumultuous. Anarchists threatened some of the priests who succeeded Father Maselli. One priest was shot at through an open window and another was driven out of town and told never to set foot in New Kensington again.

Father James Vocca, who had been called to the church on May 1, 1915, died on June 9, 1923.

On Sept. 6, 1923, Father Fusco was assigned to St. Peter's. The church was $10,000 in debt and there were only 13 families in the church register at the

time. With many families lacking access to the church, Father Fusco set up preaching stations at Logans Ferry in 1924 and in Kinloch in 1925. That same year, a preaching station was set up in the Braeburn section of Lower Burrell. That move led to the building of St. John Bosco Church in 1936, named after the saint who was canonized a year earlier.

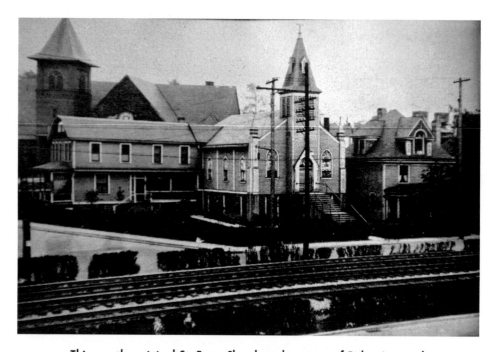

This was the original St. Peter Church at the corner of Ridge Ave. and Constitution Blvd., then known as Stanton Ave. Note the height of the railroad tracks before the 8th St. crossing was built.

Monsignor Nicola Fusco served the Mount Saint Peter parish from 1923-69.

Preaching stations were also set up the small coal-mining hamlet of Barking in Plum Township and in Glassmere, located across the river from the Alcoa plant.

The radical element gradually subsided and more Italian immigrants and others from European countries assimilated into American life.

By 1929, the church had grown from 13 families to 1,000 families. The sanctuary could seat just 200. All three masses on Sundays mornings packed the church. A balcony was opened to accommodate the overflow and supports had to be erected.

The church couldn't expand because the General Electric plant next door occupied the property. Attention then turned to a 4-acre site about 100 yards from the church to a knoll first owned by Stephen Young, a Civil War general who was friends with Abraham Lincoln.

In 1938, the land was owned by retired pharmacist David A. Leslie. When approached by the church, Mr. Leslie said that as soon as the parish collected $35,000, he would sell the land.

Two months later on Aug. 25, 1938, Leslie died. The church's lagging fundraising efforts appeared to be doomed when his widow approached the church and offered $25,000 for the property. She finally agreed to a $20,000 sale price and left the estate in April, 1939.

The parish successfully sought 5-year pledges from members to raise money for a new church. At the same time, the Mellon mansion in the Shadyside section of Pittsburgh was being torn down. John Stanish, a friend of the church who had worked at the mansion, suggested some the artifacts be conveyed to the new church.

Eventually, the demolition company agreed to donate hundreds of thousands of dollars worth of steel beams, 65 oak and bronze doors, marble and marble pillars and various art works. The church had to merely pay transportation costs to New Kensington.

On Aug. 15, 1942, the congregation moved into the new Mount St. Peter Church.

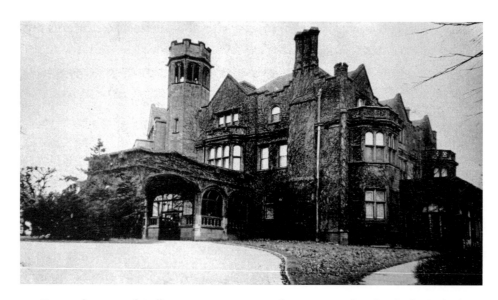

Here is the original Mellon mansion at 6500 5th Ave. in Pittsburgh. The home had entertained royalty, celebrities, statesmen and financiers from around the world.

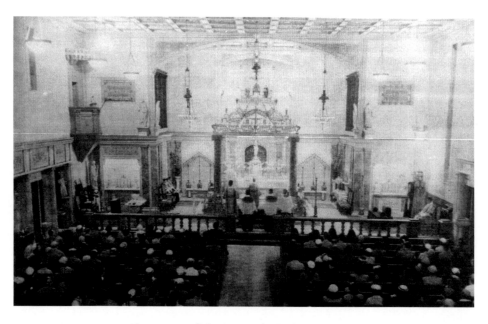

This is part of the Mount St. Peter sanctuary

Besides the spectacular Mellon artifacts, Mount St. Peter also contains the works of great artists such as Vincenzo Gemito, whose bronze Crucifix in the main church vestibule has been declared a masterpiece of anatomical art. The priceless painted ceiling of the Chapel of the Seven Sacraments is the work of Giovanni de San Pietro.

The Rt. Rev. Fusco became more and more influential in the priesthood as time went on.

He was born in Formicola, Italy on June 12, 1887 and was ordained on July 2, 1912.

Rev. Fusco was the author of six books, including a chronicle on how the new church came about, and was the editor of two Catholic weekly newspapers.

In 1959, Rev. Fusco was named a Domestic Prelate by Pope John XXIII. He went to the Vatican to take part in the Second Vatican Council in 1962.

During the 1960s, he was also named a Prothonotary Apostilic of the Catholic Church by Pope Paul VI.

Rev. Fusco retired on June 20, 1969, a few days short of 57 years in the priesthood.

He died tragically in an automobile accident near New Alexandria, Pa. on Nov. 2, 1971.

The pastor is Monsignor Michael Begolly and the parochial vicar is Gregorio Dela Cruz Soldevilla.

Worship has always been a major part of the lives of New Kensington area residents, dating back to a time before the City was officially formed in 1891.

For instance, the first United Methodist Church was started in 1853, the Logans Ferry Presbyterian Church was formed in 1854 and the First Evengelical Lutheran Church got its start in 1881.

Here's a look at other churches from 2016:

Abundant Life Fellowship in Christ Church

The church got its start on Wednesdays in the Lower Burrell home of Pastors, Rev. Roger C. Thomas Sr. and his wife, Minister Barbara A. Thomas, along with their son, Roger C. Thomas Jr. in 1990.

On weekends, the three did evangelical work in the United States and the Caribbean. The church soon outgrew their home and moved to the community recreation center on 4th Ave., New Kensington in 1991.

One year later, the church began holding its Sunday services at the former Days Inn, New Kensington preceding the formalizing of the church as a tax exempt institution in 1993. That same year, the Harvest Baptist Church building on Leishman Ave., was rented then bought and paid for by the Abundant Life congregation on Dec. 30, 1994.

The church soon expanded its services, partnering with the Arnold Lions Club for distribution on holidays to the disadvantaged, helping distribute Gideon Bibles worldwide and starting a music ministry.

In 2012, the church moved to its present location at 895 Kenneth Ave., the former First Baptist Church location where the Rev. Thomas remains the pastor.

Allegheny Valley Church of Christ

The church's congregation, which now worships on Marlboro Drive in New Kensington, began with a handful of church members from the Fifth & Beechwood Church of Christ in the Oakland section of Pittsburgh.

A minister, Gwyneth Ford, was hired from Tennessee and the congregation was officially organized Jan. 1, 1959. The congregation began meeting regularly at the Stewart Elementary School, Leechburg Road, Lower Burrell.

Due to their autonomy, the fledgling membership pooled their own resources and purchased the property along Marlboro Drive around 1961.

The parsonage was built in 1962 and the church building was completed in 1963. Singer Pat Boone appeared and performed in the church building several years later at the height of his career.

Gwyneth Ford returned to Tennessee after nine years in the pulpit.

The current pastor is Paul Barton, who began serving the church in 1996.

The Allegheny Valley Church of Christ has been on Marlboro Drive since 1963

Allegheny Valley Church of God

A Pentecostal Fundamental Church, affiliated with the Church of God in Cleveland, Tenn, is the origin of the denomination.

On Oct. 13, 1991, the church first opened in Monroeville as the Garden City Church of God. After a year, the church relocated to the Holiday Inn in Harmarville. The name was changed and the church met there for several years until it moved to 216 Catalpa St.

Pastor Carmen Butler is now serving the congregation.

Bibleway Fellowship Church

The church began in 1979 in the home of Rev. Magnolia Combs and the late James Combs in Brackenridge as a weekly Bible study group. The membership soon increased to over 50 and the organization became an official non-profit group and began meeting the Combs' backyard twice weekly in the summer of 1980.

As winter approached, the church began renting the Valley Heights Community Center on Carl Avenue in New Kensington. Three years later, the congregation bought a vacant building at 216 Catalpa Street and held their first service on Nov. 13, 1983.

With the membership still increasing, a former doctor's office at 504 8th St. was purchased. The building was gutted and renovated.

On Dec. 31, 1995, the first worship service was offered at the new, and current, location.

The pastor is the Rev. Dr. Mitchel Nickols, who is also the host of an award-winning TV series "A Nickols' Worth."

Canaan First Baptist Church

In 1930, 75 area Christians gathered to form a Missionary Baptist Church. The church was organized on Feb. 22, 1931. The Rev. Andy Spencer and the church's first mother, Sister Cornelia Murphy, gave it the name of the Canaan First Baptist Church.

The congregation grew and the move was made to 987 2nd Ave., but the Great Depression made it impossible to pay the church's rent. Consequently, the church suffered a membership loss and moved four times in five years and had trouble keeping a minister.

The church was able to raise enough money to purchase property at 781 2nd. Ave, and thrived there until it had to move to make room for the Industrial Expressway in 1969.

First Evangelical Lutheran Church

The church was established on Dec. 6, 1881, predating the city by 10 years.

It was founded by the Rev. Carl Zinnsmeister and a group of 40 individuals. The church was chartered with the Commonwealth of Pennsylvania in June, 1892. The cornerstone of the first church was laid on Aug, 7, 1892 on land donated by the Burrell Improvement Co. and completed on Oct. 1, 1893.

As the congregation grew, a new church was needed and built on the same lot, opening June 27, 1915. The church was remodeled to its current configuration in 1939. In 1956, the church was merged with the First German Trinity Evangelical Lutheran Church of New Kensington.

The current pastor is Alfred S. Petrill Jr.

Greek Orthodox Church

In 1927, church services were held by the Hellenic families in a rented hall at 852 2nd Ave. Two years later, the church moved to the second floor of

309 9th St. That same year, a charter was granted by the Commonwealth to the Annunciation of the Virgin Mary Greek Orthodox Church of New Kensington to the newly-formed church.

In 1939, church President Stamati Patsakis and the board of directors purchased the property at 1126 3rd Ave. for a new church. During World War II, the church was commended on doing such an outstanding job of selling United States War Bonds. With the Urban Redevelopment coming through in 1960, the church moved to its present location at 803-805 Walnut Street, the former home of the First Lutheran Church.

Mount Calvary Missionary Baptist Church

Originally the First Baptist Church of Arnold, the church was organized in September of 1908 at the home of Mr. and Mrs. Sam Carter and four other families with the Rev. Graves presiding.

For the next five years, the church met in an Arnold store front in the old Pickle Factory Building.

Mrs. Irene McGuigan, who operated a furniture store on 5th Ave., heard of the church's struggles and asked Mrs. Dora Waugh to get a committee of parishioners to visit her. Over the wishes of her husband and family, Mrs. McGuigan let the congregation have enough money to build on their lot at 1336 3rd Ave.

In May of 1961, Pastor Asa Roberts was called from Aliquippa as the church had to find a temporary home due to urban renewal. The Rev. Roberts came to the city after developing a bond with civil rights icon Dr. Martin Luther King Jr. when the two men's fathers preached at the same church in the South.

After moving to New Kensington, Rev. Roberts had a front row seat in Washington, D.C. on August 28, 1963 when King gave his famous "I Have a Dream" speech.

In 1966, the current building at 1150 4th Ave. opened. Things went so well for the church that the mortgage was burned on May 26, 1980.

On Nov. 16, 2014, New Kensington renamed the portion of 4th Ave. from 11th St. to the City Line as Asa W. Roberts Way.

Jehovah's Witnesses

A small group of Jehovah's Witnesses began meeting as early as 1900 in the old Odd Fellows Hall. During the next 50 years, however, the congregation moved several times, including a Kingdom Hall on Constitution Blvd. to Greensburg Road.

New meeting places were later formed in Vandergrift, Cheswick and Natrona Heights. In the 1960s, the congregation built its own Freedom Hall at 2300 Leishman Ave. The growing congregation branched out in a New Kensington branch and a Lower Burrell branch before building a larger hall in 1986 along Stevenson Blvd.

Jehovah's Witnesses have no clergy. Instead, members are trained to deliver the ministry.

Logan's Ferry Presbyterian Church

The church got its start in 1854 when the congregation originated from the Associate Reformed Presbyterian Church of North America. At an Associate Reformed Church meeting in West Newton on Aug. 15, 1854, the congregation was granted a preaching station at Logan's Ferry in Plum Township.

For the next two years, the congregation met in peoples homes and barns. In 1856, Hugh J. Logan Sr. donated a small piece of land where a meeting house was constructed along what was later known as PA Route 909.

The first communion was given on Oct. 4, 1857 and the first minister assigned to the church was Rev. James Given.

In 1980, the congregation was moved to Church St. in the former Parnassus Presbyterian Church. That church was consolidated with two other nearby churches in 1973.

The first worship service in the new church was on Feb. 3, 1980 and the membership grew. The church will be celebrating its 160th anniversary in 2016.

Pastor Robert Henry retired on Dec. 31, 2015. Rev. Timothy Swigart is serving as interim pastor. The congregation hopes to choose a permanent pastor in the fall of 2016.

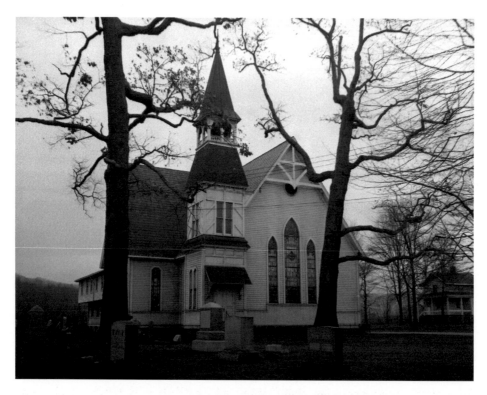

The Logans Ferry Presbyterian Church moved to the former
Parnassus Presbyterian building on Church St. in 1980.

New Kensington United Methodist Church

The first Methodist church founded in the area was the Bethel Church in 1843. Next to come along was Mount Hope in 1859, part of a circuit that served Indiana and Wilkinsburg.

A small, 35 foot by 50 foot church was built on Church St. in 1869.

Methodism grew until 1886, when a permanent pastor, The Rev. J. W. Kessler, was assigned. The early services were held on the second story of the Parnassus train station.

In 1892, the church relocated to the growing industrial center of New Kensington. The Burrell Improvement Co. gave the church lots on Ridge Ave. where a small frame church was built. It was replaced by a brick church in 1898.

From 1924 to '27, the church was remodeled and expanded its service area with a major excavation of the hillside.

A new education building and renovations to the old church were completed in 1963 and the building was dedicated on June 5, 1966.

The current pastor is Tom Dougal.

The River – A Community Church

Early in 2004, a handful of people met in the living room of Dean and Leslie Ward in New Kensington. The group considered what it would be like to begin a new church in the New Kensington community.

The River gets in name from the dedication of helping people on their journey back to God that reaches out and runs deep.

The first church service was held on Dec. 5, 2004.

The church now occupies the former Alcoa Club and Citizens General Hospital nurses residence at 200 Freeport Road.

Dean Ward remains the church's pastor.

The Salvation Army

The New Kensington Corps of the Salvation Army was founded on Sept. 26, 1899 under the direction of Capt. William Grimshaw in a vacant store on Ivy Alley. Just six years later, however, the Salvation Army closed.

The Pittsburgh headquarters in 1915 decided to build a permanent Allegheny Valley location in the fire hall at 855 4th Ave. where Clifford Lockwood was appointed captain. The membership grew until a new citadel was needed and built near the corner of 4th Ave. and 8th St.

In 1973, the Salvation Army moved to the current location at the corner of 5th Ave. and 11th St . at the former site of the "Downtown" Presbyterian Church.

St. George Orthodox Church

Immigrants from Syria and Lebanon first came to the New Kensington area in the early 20th century. Many found work in the local tin mills, where they not only found work, but food and a place to sleep inside the plant.

In 1912, the community of Orthodox Arabic-speaking first organized worship services with visiting clergy. A savings account set up by members allowed the clergy to be paid and plan for an eventual permanent worship building.

The church set up a board of directors and requested a full-time priest, granted by His Eminence, Bishop Rafael Hawaweeny of Brooklyn, N.Y., with the appointment of the Rev. Solomon Merhige. Bloser's Hall of 4th Ave. became the group's first worship place.

Members raised enough money to buy a lot on Kenneth Ave. and a church building was completed in 1918. Each church member turned over his entire paycheck to make sure the new house of worship was debt free.

In 1951, Archbishop Aftimios Ofiesh, along with board president Tom Tannas and church elders, decided the growing congregation needed a bigger building. Three years after breaking ground, the church opened its present location at 1150 Leishman Ave.

The congregation is currently served by Fr. Meletyios Zafaran.

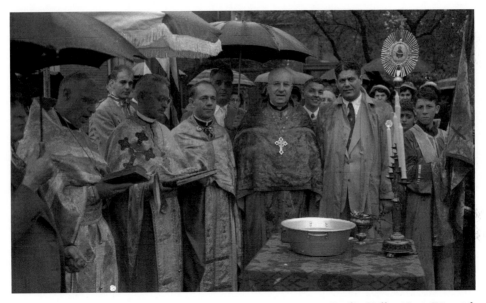

Credit: Valley News Dispatch

Rain couldn't dampen the spirits of St. George Orthodox Church officials and members on May 17, 1951 at the groundbreaking on Leishman Ave.

St. John Orthodox Catholic Church

In 1909, St. John's became the first Orthodox Catholic Church organized in the area. The following year, 1910, the first church was built in Arnold.

Since it was the only Orthodox Church in the area at the time, all nationalities were welcomed to worship there.

The parish membership continued to grow and a new church was built in the Rossmont section of the city in 1964. In 1970, the church was accepted into Orthodox Church of America. Earlier that year, the Blessing of the Sanctuary of Icons took place on Feb. 27.

The church is perhaps best known for its icons, stained glass windows and mosaics. Serving the parish is Father Nikolai Breckenridge.

St. Joseph Church

During the same year the city was formed in 1891, St. Joseph got its start in a frame building at the corner on Constitution Blvd. and Catalpa St. It began as a mission of the St. Joseph Roman Catholic Church in nearby Verona.

The congregation quickly outgrew the location and moved to the corner of Constitution and Locust St. In 1900, Father Thomas J. Kerner purchased the McCarty Farm, located from Constitution to Leishman Ave. between Locust and Walnut streets.

Under the direction of Father Francis J. Hertzog, the church added a parochial school in 1914, a rectory in 1918 and broke ground for the present St. Joseph's Church in 1922.

The church was dedicated on Aug. 31, 1924 with Bishop Hugh C. Boyle presiding. Father Hertzog remained at the church until he died in 1959 and Father Henry F. Hanse was called.

A grotto of Our Lady of Fatima facing Kenneth Ave., was dedicated on May 30, 1962.

The present pastor is the Rev. John S. Szczesny and the Parochial Vicar is Fr. Gregorio Dela Cruz Soldevilla.

St. Mary of Czestochowa Roman Catholic Church

In the early 1890s, local Polish immigrants, seeking to worship God in their native language, visited the Rev. Ladislaus Miskiewicz at St. Adalbert Church in Pittsburgh. The group requested a Polish priest, and Father Miskiewicz preached to the immigrants himself.

On Nov. 20, 1892, the society of Our Lady of Czestochowa was formed and was temporarily housed at St. Joseph's Church, the only Catholic church in New Kensington at the time. Land was purchased on Kenneth Ave. soon after Rev, Henry Citchowski was appointed pastor on Oct. 11, 1893.

The current church was built in 1912. A school was quickly added and expanded in 1922. A cemetery was established along Leechburg Road in Lower Burrell in 1927.

The present rectory was built under the supervision of the Rev. Edward Sierocki in 1957.

The current pastor is the Rev. John S. Szczesny and the Parochial Vicar is Fr. Gregorio Dela Cruz Soldevilla.

St. Paul's Evangelical Lutheran Church

The start of St. Paul's took place in January of 1909. Shortly thereafter, plans were developed for construction at 1312 Consitution Blvd.

The new church wasted little time, laying the cornerstone on June 20, 1909 and the church was dedicated on Oct. 24.

The first pastor was the Rev. Paul Succop.

The congregation continued to expand and in the late 1950s, the church bought several lots at the corner of Edgewood and Freeport roads. Ground

was broken for the present church in June of 1962 and the new building was dedicated on Aug. 18, 1963.

The church is being served by the Rev. Jack Hartman.

Tetelestai Church

The Tetelestai Church is located on East Hills Drive in the building that formerly housed the Terrace Elementary School.

Tetelestai (pronounced the TELL ess tie) is what Jesus Christ cried out from the cross moments before he died, according to John 19:30.

Tetelestai is is a New Testament Greek word meaning "finished" or "it is finished."

The church is ministered by Pastor Rick Knapp.

United Presbyterian Church of New Kensington

The church was formed in 1973 by way of a merger between the former Westminster, Parnassus and First Presbyterian churches.

All three churches had a rich history, with two predating the establishment of New Kensington.

The Westminster Presbyterian Church was founded in May of 1842 on Freeport St. Its growth made it necessary to move to the corner of 5th Ave. and 6 th St.

The Parnassus United Presbyterian Church was located on Church St. and first opened it doors in 1876.

First Presbyterian, affectionately known as the "Church Downtown," was located at the corner of 5th Ave. and 11th St.

The current building was opened in 1965 after a Christmas-time fire destroyed the building catty-corner several years earlier.

The pastor, installed early in 2016, is Wendy Keys.

Parishoners leave the first service at the former St. Andrews
Episcopal Church on April 28, 1952.

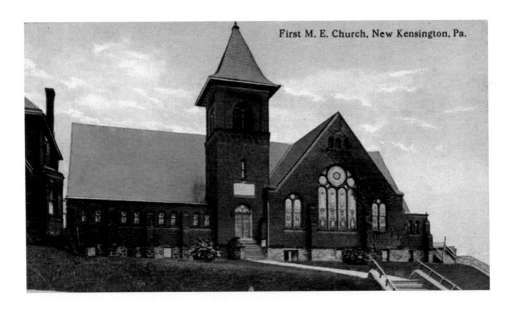

First M. E. Church, New Kensington, Pa.

First Methodist Church

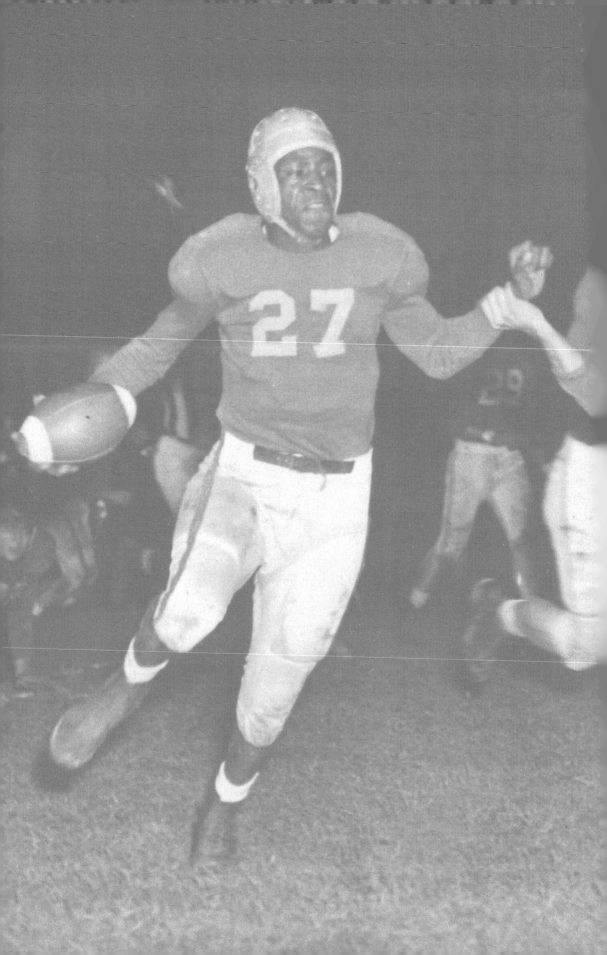

SPORTS

New Kensington has enjoyed an immensely rich sports history, starting from the early days when the YMCA was the center of indoor sporting activity and the baseball field along 7th St. was built in the 1890s for outdoor sports.

New Kensington and Parnassus high schools

High school sports have been the main focus of attention, starting with the 1906 season when New Kensington lost football games to Apollo High School, 14-0, and Sayers Business College, 6-0, according to research done by Pennsylvania Interscholastic Athletic Association historian Dr. Roger B. Saylor.

At the time, few high schools sponsored football and teams had to play business colleges, trade schools or college freshmen.

New Kensington did not sponsor high school football in 1907, but the students wanted to play anyway. The Campbell brothers, Fred Shields and Dan McCarthy organized a team. The boys were called into Superintendent M. C. Hurrell's office and were told that the school would not recognize the team.

Undaunted, they organized a game against Parnassus High, which also didn't recognize the team. The game continued but ended abruptly when Loxley Peebles of Parnassus swallowed his chewing tobacco and couldn't continue to play.

The official start of New Kensington football took place in 1908 when the team defeated Aspinwall and Leechburg while losing to Butler and Washington & Jefferson Academy. New Ken was given a place to call home in 1910 when Larry Long of Alcoa was hired as coach and a field was built

near the riverfront at Orchard Ave. and 15th St.. The team responded with its first winning season at 4-2-1.

In 1909, the first of a bitter, 20-year rivalry began with New Kensington and Parnassus with a 9-0 New Ken victory. That also turned out to be the inaugural football game for Parnassus. The teams often played on Thanksgiving morning or the Saturday afternoon following Thanksgiving Day when school wasn't in session and workers had the day off, ensuring that a maximum amount of fans could see the game.

Many have chronicled the later Ken High rivalry with Har-Brack or today's Valley-Burrell rivalry. Those are nothing compared to the early New Ken-Parnassus matchups.

There were fights, strikes and rioting – and that was just leading up to the games.

Parnassus dominated local football in the 1910s, going undefeated at 4-0-3 in 1916, followed by a 7-1-1 mark in 1917.

Both schools joined the WPIAL in 1919 and that fueled the rivalry even further as Parnassus went 8-0-0 in 1922. But that team was passed by for WPIAL title consideration because its competition was deemed not strong enough.

Parnassus made local history by becoming the first Alle-Kiski Valley high school to play a night football game at home.

On Oct. 17, 1930, the school rented a set of arc lights for the game against Har-Brack.

Har-Brack won, 21-13, but in the second quarter, Parnassus fullback Shyrocks Rybalski became the first area player to score a nocturnal touchdown.

When voters decided in 1930 to consolidate the boroughs, it meant the final rivalry game would be played on Nov. 27, 1930.

The buildup was huge. Four Parnassus youths were arrested attempting to paint Herr Stadium red and black the night before the game, then blaming it on Ken High students. Although the game took place during

the Prohibition Era, published reports indicated "fans came to the game in a salubrious state."

On a gray Friday afternoon, New Ken blanked Parnassus, 13-0 on touchdowns by Nelson and Steele, with Steele scoring on a conversion run worth just one point at the time. After the game, Parnassus Police stopped Ken High fans who came on to the field to try and take the goal posts.

The Ken High followers returned that night and removed the goal posts to their high school along Ridge Avenue. How big was the victory? New Kensington school officials gave the students the day off from school the following Monday.

Parnassus ended its football era with a fine 79-62-17 record for a .560 winning percentage.

In the 1931-32 school year, an expanded New Kensington High School, what with the Parnassus merger and the annexation of the Valley Heights and East Kensington areas, became one of the WPIAL's largest schools.

The high school enrollment that year was 1,771 in the top three grades.

The football program started off with a bang, blitzing Falls Creek, 73-0. It would be the most points ever scored by a Ken High football team. The team went 7-1-1 that season.

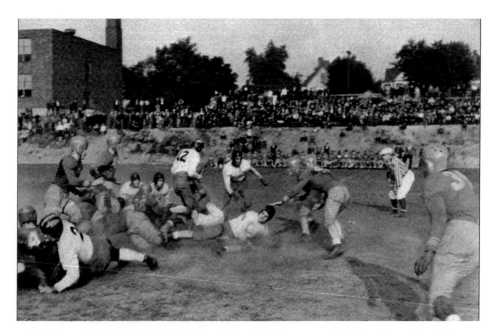

Parnassus, and later after its merger with New Kensington, played its home football and baseball games at Herr Stadium. The facility got its name from Benjamin Herr, long-time school director from that section of the community.

Here is what the stadium site looks like today. The adjacent Fort Crawford Elementary school was closed in 2014.

Cheerleaders get the crowd fired up for a big game in front of the Ridge Ave. school during the 1947 season.

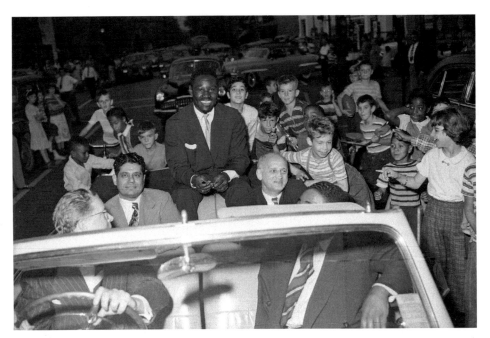

Credit: Valley News Dispatch

Fans flocked to see heavyweight boxing champion Ezzard Charles on Oct. 1, 1950 when he visited New Kensington. Seated at left in the back seat was his manager, Tom Tannas.

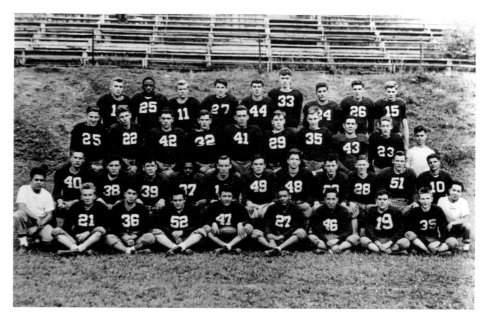

The 1946 Ken High football team became WPIAL champions when it eliminated Vandergrift. The game was moved to Forbes Field to accommodate the huge crowd.

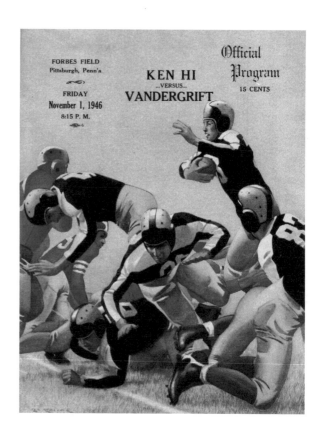

Here is a program from that historic 1946 game at Forbes Field.

Credit: Valley News Dispatch

New Kensington High School played its baseball home games on a field adjacent to Memorial Stadium. In this photo, Freeport's Guy Conti was about to be tagged out by Red Raiders catcher Dan McLaughlin as umpire Aldo Bracco gets ready to make the call. In 2016, Conti was helping to whip the New York Mets into shape during spring training in Florida at age 73.

Venerable Memorial Park has been part of New Kensington recreation
since it was dedicated on Labor Day, 1928.

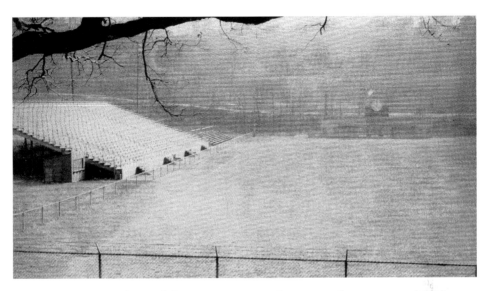

Ken High began defense of their 1946 WPIAL with a new stadium. Memorial Stadium
opened its doors on Sept. 6, 1947 with a 20-6 victory over Central Catholic.

The Night the Fog Came

There is little doubt the strangest sporting event played in New Kensington history took place on Jan. 21, 1938.

Due to unseasonably warm temperatures, a fog formed at nightfall.

Ken High was playing host to Basketball rival Arnold at the Ridge Ave. gymnasium. Interest in the game was high. Turner Book Store, located along 5th Ave., sold advance tickets to the game. All 1,800 were sold and school officials told fans without tickets to avoid coming to the site because it would add to the traffic congestion.

Fans came anyway.

The gym's windows were opened so fans could feed a play-by-play to those not lucky enough to get seats. Condensation from the fog seeped into the gym, where the floor was constructed of rubberized cork. By the end of the first half, the floor was extremely slippery.

School officials ordered the windows closed, but the damage was done: the fog was trapped inside the gym. Players had trouble keeping their footing in the third quarter. At the quarter break, Ken High coach Dutch Glock conferred with game officials and it was decided to call the game with Ken High leading, 23-18.

Arnold was unhappy because the Lions had started to rally. One of the New Kensington players had already fouled out and two others were in foul trouble.

It was decided that if the game would be made up in its entirety if it would help decide the section title. Har-Brack won the section by two games and the Great Fog-out was never made up.

The game was later featured in "Ripley's Believe It or Not."

The Fletcher Era

After an 0-8 season in 1938, New Kensington lured Don Fletcher away from Windber High School to take over the football program. Fletcher had been a standout player for the legendary football program at Massillon High School in Ohio. He later played at Carnegie Tech.

It didn't take long for Fletcher to turn around the football fortunes, posting a 6-2 record in his first season as the school officially adopted the nickname "Red Raiders."

It started a stretch where Ken High had just one losing season in 12 years. The Red Raiders were still playing at Herr Stadium when Fletcher arrived. Because it was below street level, the field was slow in drying after a rainstorm. When Vandergrift sustained a tough loss there in 1934, the Blue Lancers staff referred to the field as a "duck pond." The name stuck as Ken High fans used the term to affectionately describe their home field advantage.

Soon into Fletcher's run, Red Raiders home games were moved to George Leslie Stadium in Arnold. It set the stage for what would be an incredible 31-3-1 surge by the football program.

In 1945, Ken High opened with a loss to North Catholic, not a WPIAL school at the time. But the Red Raiders would go on to win their next seven games and earn a berth in the WPIAL finals against Donora. New Kensington suffered a 38-6 setback against the Dragons, but that would be the last Red Raiders loss until the middle of the 1948 season.

In 1946, Ken High would win the first of two consecutive WPIAL football championships. The Red Raiders were 7-0 going into the final week of the regular season against Vandergrift, also undefeated. Since the two schools were the only undefeated, untied teams left in the WPIAL's big school ranks, the game would be the de facto title game.

The dilemma was where to play the game. Interest was high and Leslie Stadium was too small to accommodate the huge crowd that was expected. The WPIAL moved the game to Forbes Field where 17,967 watched Ken High prevail, 18-0.

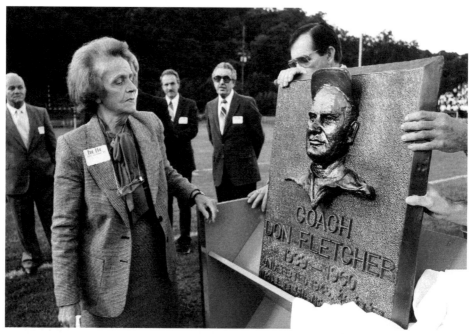

Marjory "Billie" Fletcher admires a bust of her late husband, Don, dedicated on Aug. 29, 1986 at Valley High Memorial Stadium. Fletcher compiled a 113-65-12 record in 22 seasons as Ken High's coach, including two WPIAL titles. Fletcher was a native of Massillon, Ohio, where high school football is so big that when a baby boy is born in the town's hospital, the boosters club puts a little football in the child's bassinet that says "Future Massillon Tiger."

The 1947 season was a special one for New Kensington High School. Not only did the team defend its WPIAL title, but Memorial Stadium, a beautiful, world-class facility, opened on Sept. 6 as the Red Raiders defeated Pittsburgh Central Catholic, 20-6.

Vince Pisano scored the stadium's first touchdown on a 9-yard run three minutes into the game.

Ken High continued its winning ways throughout the regular season and qualified for the WPIAL championship game.

New Ken's opponent would be none other than cross-river rival Har-Brack. Oddly enough, the two schools didn't play each other during the regular season because the rivalry had become so fierce that officials decided to let things cool down a bit.

More than 15,000 came by car, by bus, by streetcar and by train to Forbes Field as the Red Raiders brought home the gold with a 27-0 victory. The team was selected as the best scholastic football team in Alle-Kiski Valley history in a 1989 Valley News Dispatch readers' poll.

It looked like a third straight WPIAL title was a possibility late in the 1948 season. But after a hard-fought win at Ambridge, Ken High's 24-game winning streak came to a halt with a loss against Vandergrift.

A remarkable total of eight players from that 31-3-1 run matriculated to Michigan State University, where they helped the Spartans win the 1952 national collegiate championship.

Fletcher's last undefeated team came in 1957. It was the first year of the new high school, built adjacent to the football stadium, by then a decade old.

Excitement soared during the off-season after the Red Raiders won their final three 1956 games and workmen were putting the finishing touches on the high school building. The '57 squad started out with wins over Vandergrift and Johnstown, but then a deadly strain of the Asian flu began circulating throughout Western Pennsylvania.

Ten Leechburg High School band members became ill shortly after leaving the A-K Band Festival in late September at Memorial Stadium. Soon, schools began to virtually close with hundreds and hundreds of students from local school districts affected. Three consecutive games were postponed as flu germs penetrated locker rooms throughout the regions and schools couldn't field teams.

Ken High finally played its third game of the season on Oct. 25 as the Red Raiders defeated Har-Brack as the flu finally dissipated. The regular season was supposed to end at Latrobe on Nov. 8, but the Red Raiders won subsequent make-up games against Hempfield and Turtle Creek. A rescheduled game loomed against Greensburg, but a victory there and a WPIAL title game would have forced Ken High to play four games in 12 days, an unappetizing predicament for school officials and the school called it a season at 7-0.

Fletcher would retire after the 1960 season and handed over the reins to assistant Dick Brown, Following a legend isn't easy, but Brown piloted Ken High to an All-West Conference title in 1961. He would be the school's last head football coach.

New Kensington played its final football game on Nov. 4, 1966, a 40-7 winner over Plum.

Ken High's all-time football record was 249 wins, 206 losses and 38 ties. The school played 89 different high schools and 13 schools such as Mooseheart, Ill., the Carnegie Tech freshmen and various business and trade schools.

And don't forget the no-decision game when the Parnassus player swallowed his chew in 1907!

Willie Thrower

New Kensington is the home of the first black quarterback in NFL history.

On Oct. 18, 1953, Thrower was playing for the Chicago Bears when coach George Halas inserted Willie into a game against the San Francisco 49ers. He completed three passes in eight attempts as a long-standing barrier was broken.

Thrower made such an impression with his strong throwing arm that the usually-jaundiced crowd at Wrigley Field began to chant "Willie, Willie," wanting to see more of the New Kensington native.

Thrower would get into one more game later in 1953. But the Bears signed another back-up quarterback in 1954 to starter George Blanda of Youngwood, Westmoreland County.

Willie then played for several Canadian teams before a shoulder injury ended his career in 1957.

But before he stepped on an NFL field, there were obstacles for Thrower to overcome, let alone trails to blaze.

Coach Don Fletcher saw Willie's talents early, inserting him as a freshman at halfback in 1945 in a program that would soon be known throughout the nation. Thrower always seemed to have that knack of coming up big in the big games.

When New Ken needed a win in the 1945 regular season finale against Redstone High of Fayette County, the Red Raiders fell behind early and had to switch to a passing attack out of the single-wing offense, much like the Wildcat offense of 2016. Thrower's passing led to a 26-20 Red Raiders victory and a berth in the WPIAL title game.

The 1946 team was dominant, beating opponents by an average of 26 points per game en route to the WPIAL title. The closest game that year was a 19-6 victory over rival Har-Brack. Fletcher said that he thought the '46 team was his best as they outscored the opposition, 232-25.

Sour oranges

The 1946 season didn't exactly have a happy ending.

New Kensington was becoming a nationally-known program. Promoters of the Peanut Bowl in Miami's Orange Bowl invited Ken High to the Sunshine State for the Christmas holidays.

There was one stipulation – because of Florida's Jim Crow laws, no integrated teams could play on the same field. That meant New Kensington would have to leave Thrower and Flint Greene behind. Team leaders and Fletcher agreed that if the whole team couldn't go, nobody could go and the team declined the invitation.

The Red Raiders came back for more in 1947, rolling through the regular season then getting a date against Har-Brack for the WPIAL championship at Forbes Field. More than 15,000 fans braved 17-degree weather on Thanksgiving Day to watch Ken High blank the Tigers, 28-0.

Thrower came up big, completing 12 of 19 passes for two touchdowns, both to Vince Pisano. Willie scored a rushing touchdown and intercepted two passes.

It appeared the Red Raiders were rolling to their third consecutive WPIAL title after playing Allentown's William Allen High School to a 7-7 deadlock. Allen wasn't a WPIAL school, so Ken High was still alive for title consideration. After a hard-fought, 25-19 victory at Ambridge, the Red Raiders were derailed by a 2-6 Vandergrift team in a 20-14 shocker.

Postseason accolades came Thrower's way. He was named all-WPIAL, and first-team Associated Press all state. Willie was also named to the Wigwam Wiseman All-American team, a selection he was most proud of.

But Thrower suffered another racially-motivated snub when he was named captain of an all-star game in Corpus Christi, Tex. When game organizers found out he was black, they told Willie he couldn't come to the game.

While at Michigan State in 1952, Thrower became the first black quarterback in Big 10 Conference history, passing 48 times, completing 29 for 400 yards, helping the Spartans to the national title.

After his playing career ended, Thrower entered social work in New York City before returning to New Kensington owning two taverns and working in construction. He lived in quiet obscurity, many forgetting or younger people not knowing of his accomplishments.

Willie Lawrence Thrower died on Feb, 20, 2002 at age 71.

A number of community members wanted to make sure he wasn't forgotten again. New Kensington resident Will Varner spearheaded an effort to raise money for a statue in Willie's honor.

It was sculpted by New Kensington native Stephen Paulovich and stands inside Valley High Memorial Stadium. It was dedicated on Sept. 28, 2006.

A historical marker was also erected at the Valley High entrance. Several years after his death, he was inducted into the African-American Hall of Fame in Harlem.

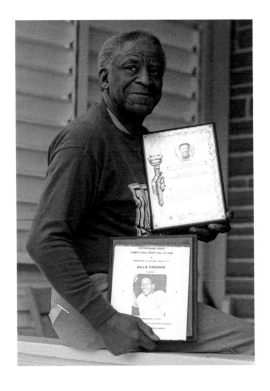

Willie Thrower sits on his Parnassus porch displaying plaques from the Alle-Kiski Valley Sports Hall of Fame and the Westmoreland Chapter of the Pennsylvania Sports Hall of Fame.

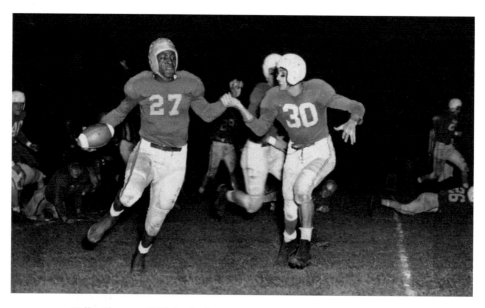

Willie Thrower (27) looks for some running room in a 1947 game.

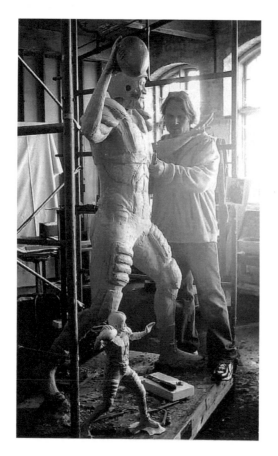

Sculptor Stephen Paulovich,
a 1979 Valley High School graduate,
works on the Willie Thrower statue in
his Louisville, Ky. Studio.

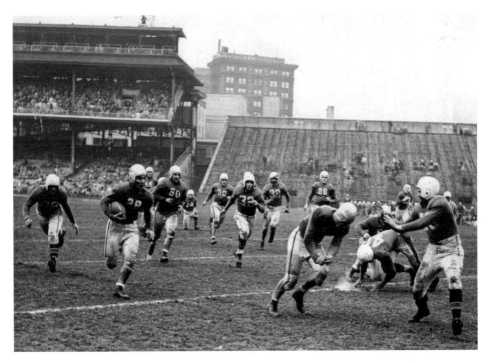

Vince Pisano skirts right end at Forbes Field in the 1947 WPIAL championship game against Har-Brack.

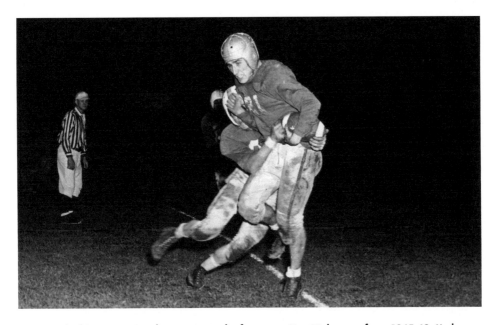

George 'Cub' France was a key starter in the four great Ken High years from 1945-48. He later played for Michigan State and was an educator in the Freeport Area School District for 38 years. The entire, 4-man backfield from that era is enshrined in the A-K Valley Sports Hall of Fame.

Defensive tackle Greg Meisner poses in his Los Angeles Rams jersey on Oct. 1, 1987 during the NFL players strike.

Credit: Valley News Dispatch

Greg Meisner was always proud of his New Kensington roots, though he played pro football on the West Coast. "Every time I came home I'd see the sign that says "Welcome to New Kensington" and that sign meant so much to me. Every time I played, I played for my community and the great athletes who played here before me," Meisner said in a 2007 Valley News Dispatch interview.

An all-around athlete at Valley, Meisner was named to the 1976 Associated Press all-state second team and played on the Big 33 West team in 1977.

While at Pitt, the Panthers compiled a 39-8-1 record over his four seasons. The 1980 Pitt team finished No. 2 in the country. That team had 51 players who were either drafted by the NFL, signed as an undrafted free agent or were offered an NFL tryout.

Meisner was drafted in the third round of the 1981 draft. He would go on to play eight seasons with the Rams, including the 1985 NFC title game when LA lost to the Chicago Bears at chilly Soldier Field.

After eight seasons in Los Angeles, Meisner signed as a Plan B free agent with the Kansas City Chiefs, where he played under defensive coordinator Bill Cowher. His 11th and final NFL season was in 1991 with the New York Giants.

He has been athletic director at Hempfield High School for the past 11 years.

Basketball

New Kensington residents have excelled in many sports, but none more than basketball. The records compiled by New Kensington High School and its successor school, Valley, have been nothing short of outstanding.

Ken High won WPIAL titles in 1930 and '34 and was the runner-up in 1932. Valley won the WPIAL in 1993, was the runner-up in 1975 and '76, then won the state championship in 1979. Under coach Carl "Dutch" Glock. New Kensington had only one losing season in 19 years, compiling a 321-102 record.

From the 1953-54 Ken High season until the 1986-87 Valley season, there was not one losing season during that 33-year span. In the first 12 years of Valley alone , the school won 232 games and lost 62 for a .789 winning percentage.

The first New Kensington High School basketball team was in the 1909-10 season. The team played at the old YMCA gym. The facility held about 50 spectators and was illuminated by gas lights. The "Y" conducted a lecture course the same night the basketball games were scheduled. Because of the noise generated by players and fans, the YMCA withdrew permission to use the floor and basketball was discountinued for the 1912-13 season.

Entering the big time

A significant day in New Kensington High School sports history occured on Jan. 10, 1919 when the old, multi-sport Alle-Kiski League was disbanded. Ken High, along with Vandergrift, Ford City, Kittaning, Parnassus Apollo, Tarentum and Oakmont were all admitted to the WPIAL. Now New Kensington could play for the section titles and other championships.

The first WPIAL title came in 1930 when the school's basketball team defeated Har-Brack in a section tiebreaker game before an overflow crowd at Tarentum High School. Only section winners were admitted to the WPIAL playoffs at the time.

That season, coach Glock rarely substituted for the starting lineup of Uhlan "Babe" Dayoub, Harold "Whitey" Wilson, Billy Ames, Don McCandless and Phil McLaughlin. The quintet was dubbed the "Five Fighting Fools" by fans.

In the semifinals, New Ken defeated Uniontown in four overtimes, 23-22, on a shot by Wilson. That allowed the team to earn a slot opposite Duquesne for WPIAL honors at Pitt Pavilion, a 4,000-seat court located beneath Pitt Stadium. Ken High brought home the crown with a 38-34 decision over Duquesne.

In 1932. Braddock won the title game over New Kensington, 29-21. But two years later, the title was again brought back to the Aluminium City with a 26-22 victory over Ambridge. Through the years, an intense rivalry developed with Har-Brack and Ford City that continued into the 1960s.

It didn't take Valley High School long to get on the basketball map. In the school's first season, 1967-68, the new school won the section tiebreaker over Har-Brack, 75-60, in what proved to be the final game in history for the Natrona Heights school.

The set up a collision with Farrell, one of the most successful programs in state history, on March 4, 1968. The Vikings took the Steelers into overtime and were down by a point with time running out. Al Jackson launched a 23-foot shot from the Civic Arena floor and sent shock waves throughout the WPIAL with the winning basket in a 58-57 triumph.

In 1975, Valley lost to Highlands on the final day of the regular season and were forced to play a tiebreaker game against North Hills in which Valley emerged with a 64-49 victory. Wins over South Hills Catholic and Hempfield followed, but the Vikings lost the finals to Uniontown, 68-61. Valley made the PIAA playoffs and opened with an 84-54 victory over Meadville, with B.B. Flenory pouring in 49 points.

But in the second round, Valley lost in overtime to Pittsburgh Fifth Avenue, 69-68, in a game punctuated by ugly inciddents and misbehavior by the Fifth Avenue fans that caused several game delays. Still, the team was voted the best in Alle-Kiski Valley history in a Valley News Dispatch focus group.

Valley's Al Jackson is overcome with emotion after his game-winning shot against Farrell in the 1968 WPIAL playoffs at the Civic Arena.

In 1976, Valley finished the regular season with a 21-1 record and drew a first round playoff bye. The Vikings defeated Sto-Rox 83-73 at the Civic Arena and got by Monessen, 77-75, in the semi finals. That put Valley in the title game against Farrell. This time, the Steelers prevailed, 58-53. It was on to the PIAA playoffs, where Valley overwhelmed Warren, 78-54, setting up a rematch with Fifth Avenue. This time, without incident, the Archers won 76-67 en route to the state title.

Valley finally won a state championship in 1979, but the Vikings did it the hard way. They lost a 50-48 game against Burrell in the WPIAL quarterfinals and had to play in a 4-team, mini-bracket with the other three quarterfinal losers. Valley won there, and entered the state playoffs and beat Altoona, South Hills, Schenley, Beaver Falls, and finally, Allentown's William Allen to win the state title, 72-66, at the Civic Arena. Billy Varner scored 28 points to lead Valley.

The Valley Vikings celebrate their state championship on the Civic Arena floor moments after a 72-66 victory over Allentown's William Allen High School.

Buddy Jeannette

Harry Edward 'Buddy' Jeannette was born on Sept. 15, 1917 in New Kensington.

He helped Ken High win the 1934 WPIAL basketball title with a 26-22 victory over Ambridge. While wearing the Red & Black of Ken High, Jeannette's teams compiled a 53-10 record.

After graduation from New Kensington, Jeannette played at Washington & Jefferson College. He then went on to play 13 years of pro basketball in the National Basketball League, the forerunner of the NBA. Jeannette's career included stops at Detroit, Cleveland, Fort Wayne and Baltimore, where he was a player coach for three seasons in the Basketball Association of America (BAA).

In 1948, he became the first player-coach to win a professional basketball championship.

After his professional days ended, Jeannette coached Georgetown University for four seasons, piloting the team to a National Invitation Tournament berth in 1953.

He returned to the professional ranks and coached the Baltimore Bullets of the NBA twice and later the Pittsburgh Pipers of the American Basketball Association.

Jeannette was inducted as part of the Alle-Kiski Valley Sports Hall of Fame's inaugural class in 1970 and the National Basketball Hall of Fame in Springfield, Mass., in 1994.

He died in Nashua, N.H. on March 11, 1998.

Buddy Jeannette, last row on the left, was part of the 1932 Ken High
basketball team that was the WPIAL runner-up.
Other team members are: front row left: Lou Surowski, Alvin Shukis, Fred Tomkins,
Willie Walatis, John Ross, and coach Carl 'Dutch' Glock; middle row Joe Ross, Roy Stitt,
Chuck Waugh, George Easley; last row, Jeannette, Andy DeFazio, Ralph Fritz.

B.B. Flenory

Flenory first earned national recognition as a ninth-grader in 1973 by scoring 81 points in a junior high game against Deer Lakes. What's more, Flenory sat out the first three minutes of the game because he didn't wear a necktie to school that day.

The feat got him a spot in Sports Illustrated magazine's Faces in the Crowd section. His accomplishments caught the eye of a private school, Robert Louis Stevenson in Pebble Beach, Calif. Flenory was flown to the West Coast with his father, Chuck, as Stevenson tried to recruit him, but B.B. decided to stay home.

And people in New Kensington were glad he did, leading the Vikings to the WPIAL title game in 1975 and '76. Flenory had the ability to dazzle crowds with outside shots and slashes to the hoop in the smallest of defensive openings.

He finished with 1,846 career points at Valley, setting a school record of 52 in a 1975 game against Norwin. The mark still stood in 2016. Had the 3-point basket been in effect then, he almost certainly would have eclipsed 2,000 points.

Flenory went to Duquesne because he wanted to continue playing close to home. He scored 1,382 points for the Dukes in basically three seasons because he was injured during his freshman season.

As a pro, Flenory played five seasons in Venezuela.

He was named to the Alle-Kiski Sports Hall of Fame in 1997, the WPIAL Hall of Fame in 2010 and was named as part of Duquesne's All-Century team in 2016.

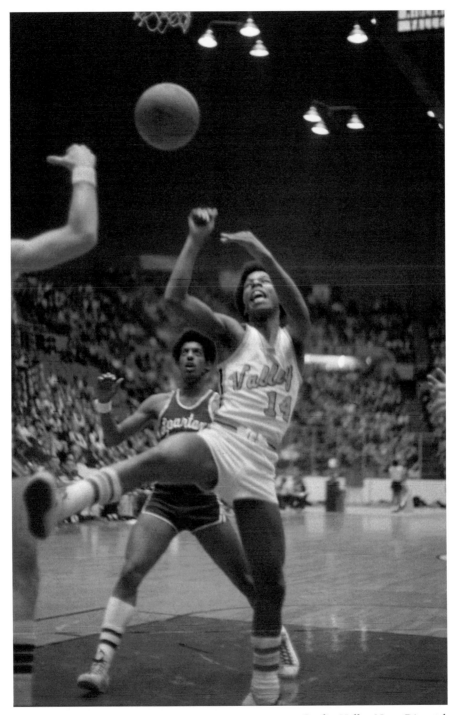

Credit: Valley News Dispatch

Valley's B.B. Flenory gets past Hempfield's Edd Buggs at the Civic Arena in
the WPIAL semifinals on March 3, 1975.

Tom Pipkins

Pipkins, like Flenory, wowed junior high crowds before he ever put on a Valley High uniform.

In his varsity debut on Dec. 8, 1989, he brought the crowd at Highlands High School to its feet with a monstrous dunk and didn't stop until he owned the WPIAL record of 2,838 career points.

On opening day of his senior season, Dec. 11, 1992, he took a pass from teammate Billy Coury and slammed the ball through the hoop to reach the 2,000-point mark. Next up was the WPIAL all-time record of 2,376 points.

Before a packed house at Valley on Jan. 29, 1993, that included cars with out of state license plates in the parking lot, Pipkins took an alley-oop pass from Coury designed by coach Tom Myers for the occasion and set the new scoring record.

Later that season, Pipkins and his teammates became the first Valley High School team to win a WPIAL title with a 52-46 win over Seton-La Salle at the Pitt Field House. In a pivotal third quarter play, Rebels guard Eric Binkowski was charging downcourt for an easy lay-up. But Pipkins came out of nowhere, leaped over Binkowski and swatted the ball away from the hoop – and Valley was on its way.

The Vikings would go on to the state championship game, losing to Pottstown. From there, Pipkins went on to Duquesne University where he led the scored 1,828 points to rank third in Dukes history.

Pipkins was inducted into the Alle-Kiski Valley Sports Hall of Fame in 2015.

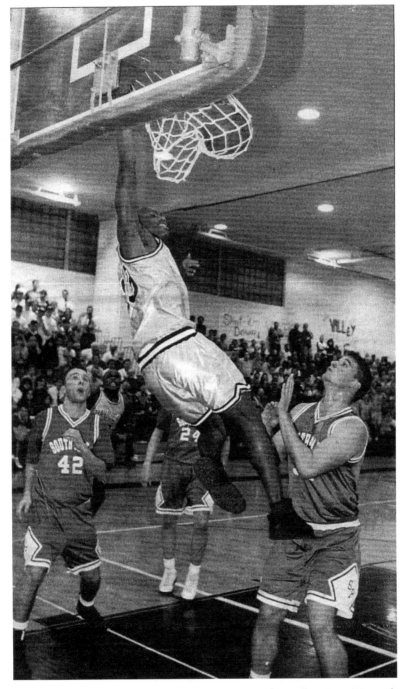

Credit: Valley News Dispatch

Tom Pipkins slams the ball through the hoop to set a new WPIAL scoring record on Jan. 29, 1993 against South Park.

Tom Myers speaks to his team during a time out in the PIAA Class AAA semifinal against Hickory on March 30, 1993 at the Pitt Field House. Several weeks earlier, Myers, a 1964 Ken High grad, coached Valley to the WPIAL title.

Valley's Bill Varner moves to the hoop against Burrrell's Joe Myers in a showdown at the Civic Arena. Varner later went on to Notre Dame and played 16 years in the European pro league.

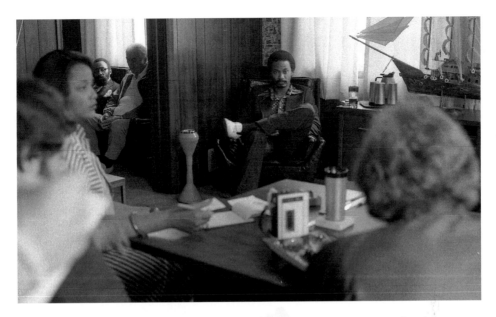

Joe Gilliam relaxes before a news conference on May 24, 1978, when he
signed with the semi-pro Pittsburgh WolfPAK team.

After dazzling Steelers fans in the first six weeks of the 1974 with his play, supplanting future Hall of Fame quarterback Terry Bradshaw, Joe Gilliam lost his starting job after changing game plans and schemes that were different than what Steelers coaches were looking for.

Cut after the 1975 season, Gilliam soon ran into despair with drug and alcohol abuse. He was cut by the New Orleans Saints in 1976 and '77, but appeared on his way to a comeback in 1978 after signing with team owner Robert Baker, President of North American Fencing. Sellout crowds in mid-summer packed Valley High Memorial Stadium to watch Gilliam display the ability he showed to coach Chuck Noll four years earlier.

In the team name, Pittsburgh WolfPAK, the 'P stood for Pittsburgh and the 'AK' the Alle-Kiski Valley. Newspapers and Cable TV covered the games and the WolfPAK was 5-1 when Gilliam left the team after a dispute with coaches. He fell into further despair, reportedly living under a bridge in Baltimore for two years and making news occasionally with arrests. After claiming to be "clean and sober" for three years, Gilliam died of a heart attack on Christmas Day, 2000. But for a few fleeting weeks in 1978, Gilliam treated New Kensington area fans with plenty of thrills.

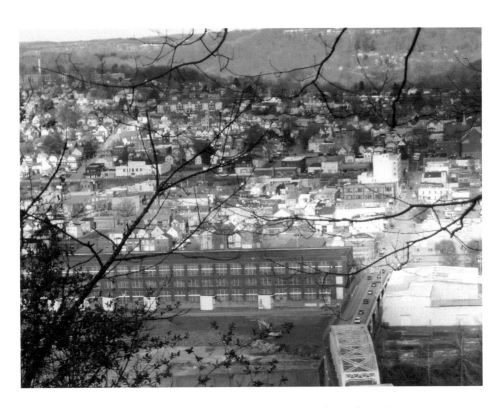

New Kensington from the Rachel Carson Trail, April 12, 2016

WA